IMAGES
of America

ST. CHARLES
CULTURE AND LEISURE IN
AN ALL-AMERICAN TOWN

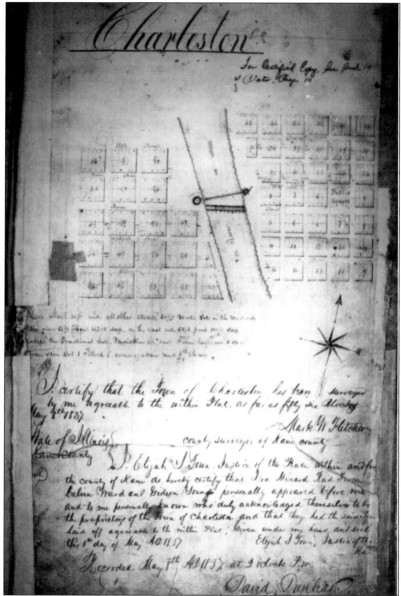

In 1834, Evan Shelby from Indiana, Ira Minard, and Read Ferson from Vermont founded the town. Shelby's pioneering spirit led him to the valley in 1833. Minard and Ferson were attracted to Chicago and, following successful real estate transactions in the Loop, they ventured west in search of additional business opportunities. The first name chosen for the new community was Charleston, after a town in Vermont. In 1839, they learned that another settlement with a similar name in southern Illinois had been established. They considered Ithaca as an alternative, but it was voted down by the German settlers as the "th" was too hard for them to pronounce, and St. Charles was chosen instead. The photograph above depicts the first town plat. Mark W. Fletcher came to the valley from Vermont in 1835 and settled in Round Grove near what is now Dunham Road. A graduate of Dartmouth College, Fletcher completed the first survey of the town in the spring of 1836. It was recorded in Geneva on May 8, 1837.

IMAGES
of America

ST. CHARLES
CULTURE AND LEISURE IN
AN ALL-AMERICAN TOWN

Costas Spirou

ARCADIA
PUBLISHING

Published by Arcadia Publishing
Charleston, South Carolina

Printed in the United States of America

Library of Congress Catalog Card Number: 2005922562

For all general information contact Arcadia Publishing at:
Telephone 843-853-2070
Fax 843-853-0044
E-mail sales@arcadiapublishing.com
For customer service and orders:
Toll-Free 1-888-313-2665

Visit us on the Internet at www.arcadiapublishing.com

St. Charles has distinguished itself as an outstanding environment for family living. It is in this spirit that this book is dedicated to Jack, Tara, MaryEve, and Stelios.

CONTENTS

ACKNOWLEDGMENTS

This project would not have been realized without the contributions of numerous individuals. First, I want to thank Julie Bunke, curator at the St. Charles Heritage Center & History Museum. Julie provided enormous assistance, not only by contributing the introduction to this book, but also by communicating unique insights into the community, as a result strengthening the quality of this work. Her assistance in accessing various historical materials proved invaluable. Natalie Gacek, educator at the center, also assisted my research efforts, offering key perspectives on various historical aspects. Without their guidance, this project would not have been realized. The St. Charles Heritage Center and the entire St. Charles community are indeed fortunate to have these two committed professionals. Their outstanding work helps to effectively preserve and present the community's history and heritage.

I also want to thank the center's board of directors for supporting the initial project idea. I want to recognize the work of interns Elizabeth Porter and of Justin Sikora who digitized the images, substantially improving the process of accessing the collection. My appreciation is also extended to acquisitions editors Elizabeth Beachy and Samantha Gleisten at Arcadia who have been most helpful throughout the completion of this project. I would also like to thank Patty Thayer from the St. Charles Convention and Visitors Bureau for providing assistance with photographs.

On a personal note, I want to acknowledge my parents Ploutarchos-Stelios and Yvonni Spirou for their value of education, as well as Anthony and Mary Dades and Stacy Popovich. My deepest appreciation goes to my wife Patrice who has always been supportive of my intellectual inquiries, even though my project engagements seem endless at times. It has been truly special to share together a strong community interest and live in St. Charles, the "Pride of the Fox," and the "Beauty Spot of the Fox River Valley."

References:
Beckstrom, Betty. *The Mayors of St. Charles.* St. Charles Historical Society, 1976.
Davis, Alice. *Growth and Settlement of St. Charles*, St. Charles Historical Society, 1940.
St. Charles: Beauty Spot of the Fox River Valley, St. Charles Chamber of Commerce, 1926.
Edwards, Wynette. *St. Charles, Illinois*, Arcadia Publishing, 1999.
Hotel Baker Dedication Book June 2, 1928. Kane County Chronicle, 1928.
St. Charles Country Club, 1924. Published by the St. Charles Country Club, 1974.
Pearson, Ruth Ann. *Reflections of St. Charles.* Elgin: Brethern Press, 1976.

INTRODUCTION

St. Charles: Culture and Leisure in an All-American Town serves as a retrospective of the history of industry and recreation in our great city. The period from 1880–1940 was a time of rapid growth in the industrial dynamics of the town. This brought with it a surge in the towns' population and therefore the makeup of the cultural background of its inhabitants. Belgians working in the iron foundry brought with them Rolle Bolle, Lithuanians shared their love for pigeon racing, and the Swedes of the town were known for their civic associations.

St. Charles has had a long reputation as a getaway to those facing the everyday turmoil of city life in Chicago. Just a mere 40 miles west of Chicago, St. Charles offered its visitors the gracious waters of the Fox River as well as the several resort communities that sprang up along its shores. These communities included Rainbo Springs, the Pinelands, and Camp Sokol, to name just a few. The influx of visitors brought about a need to accommodate the growing recreational needs of the people. To meet these needs, local benefactors constructed the Hotel Baker with its elegantly appointed rooms, which offered a bit of the sophistication of the city in what was considered to be small-town America. The Arcada Theater provided every man, woman, and child a glimpse into the glamour that was Hollywood.

It is our hope that the reader be transferred briefly back in time to the St. Charles of yesterday and gain an understanding of what life was like for those who came before us. Before the days of television and cell phones, life was simple, sometimes even described as lazy.

This book is unique in that numerous photographs appearing in the work have never been published in any previous effort to tell the history of St. Charles. Costas Spirou spent many hours researching and recording historical events exclusive to our town, as well as carefully selecting images from the St. Charles Heritage Center's vast archives of photographs; he was vigilant to not duplicate what has been done in the past.

In closing, I would like to thank you for purchasing a copy of this book, as you are helping to support our museum's mission to collect, preserve, and present the history of St. Charles, Illinois.

Julie Bunke, Curator
St. Charles Heritage Center

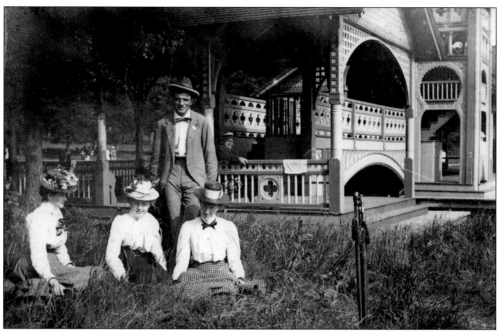

In 1940, Alice Davis reflected about the future of St. Charles: "But the same natural beauty of our river town is here, the same spirit of honest pride and independence exists, and the same love of home and town thrill us. As we have kept the natural beauty so we will hang onto the St. Charles spirit. Public spirited citizens, some with money, more with energy and loyal fondness will increase its attractiveness and keep it a true home town." Here, citizens enjoy the outdoors in front of the pavilion at Pottawatomie Park, *c.* 1900.

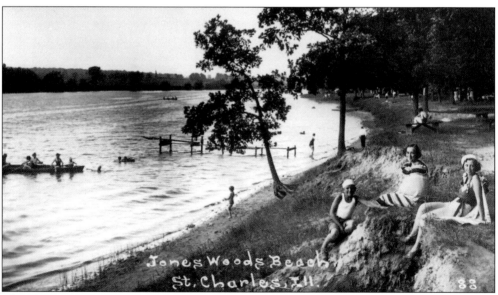

This photograph of Jones Woods Beach, located north of Pinelands summer camp on the east side of the river, shows women and children relaxing along the shores of the Fox. Jones Woods was names for Steven Jones (1813–1877), a prominent lawyer in St. Charles, the man credited with naming the town in 1839.

One

TURN OF THE CENTURY ECONOMIC AND SOCIAL DEVELOPMENT

The goal of this chapter is to provide the reader with a glimpse into life in St. Charles between 1880 and 1920. Emphasis is placed on economic and social developments during that period and includes insights into the large and small businesses that operated in town, as well as the religious activities of the residents and educational advancements.

A number of mills provided employment for St. Charles residents during the early days, including Stewart Mill and Fredenhagen Mill along the east side of the river. Most of the early immigrants (1840s) arrived from Ireland and Sweden, with later immigrants from Germany, Denmark, and Scotland (1860s). By the latter part of the century, new residents arrived from Belgium and Lithuania, helping the population to grow. In 1880, there were 25 Swedish families in town. Between 1860 and 1900, the population increased by 800 to 2,675 residents.

By the end of the nineteenth century, farming was giving way to industrialization. New businesses included factories like the St. Charles Fixture Company, the National Milk Sugar Company, St. Charles Condensing Company, Crown Electric Manufacturing Company, The Cable Piano Company, Heinz Cut Glass, Moline Malleable Iron Company, and others. Many family businesses also sprung up in town during that period, including Colson's Dry Goods Store, Wilcox and Munn Grocery Store, Anderson's Dairy, and Gartner Bakery. These developments, along with the introduction of rail transportation and the automobile, helped transform St. Charles into a burgeoning community.

On the educational front, St. Charles benefited extensively from the commitment and generosity of Charles H. Haines, who served as mayor from 1889 to 1891. In the 1880s, two districts operated separately on the west side (West Side School) and east side (East Side School) of town. Haines donated land and contributed financial resources that resulted in the

consolidation of the districts in 1897 and the construction of the Charles Haines School in 1899. Continued enrollment increases necessitated the construction of a west side school in 1911 named the Evan Shelby School. Children in the rural west were served by a school built in Wasco (1906) and the Little Woods School District was organized in 1866 to the northeast of town.

The first known church in St. Charles was a small building at East Main Street and Third Avenue. The facility was used by all societies but was soon abandoned since it was utilized as a school. Father Clark preached there; some say there had been preaching in the vicinity as early as 1834. The Congregational Church (1848), Old St. Patrick Church (1851) and St. Patrick's (1909), the Free Methodist Church (1882), and the Swedish Lutheran Church (1905) represent formal religious facilities that allowed St. Charles residents to exercise their religious beliefs during this period.

While these may be considered as the "pioneer churches," it should be noted that many other denominations received the services of traveling preachers from larger communities in the region. A Baptist Church was erected in 1853 on the northwest corner of Second Avenue and Walnut Street. The building was enlarged in the summer of 1876, but membership dwindled around the turn of the century.

St. Charles experienced growth in the latter part of the 1800s as a result of the hard work ethic of its residents and a commitment to the future. The town possessed many attributes similar to those of other communities in the metropolitan region and across the country: the impact of European immigration, industrialization, a strong religious faith, and a belief that education would help the community to grow and its residents to prosper.

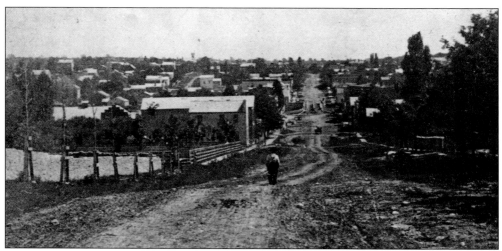

In the 1840s, St. Charles was a favorite stop for farmers taking their grain from DeKalb to Chicago. Slowly, the community emerged as the most important town in the county, and in 1840 it was larger than Elgin, a center of economic activity. The village was chartered in 1850. This view of the town is from the west. The bridge is visible at the bottom of the hill as is today's Lincoln Park to the left.

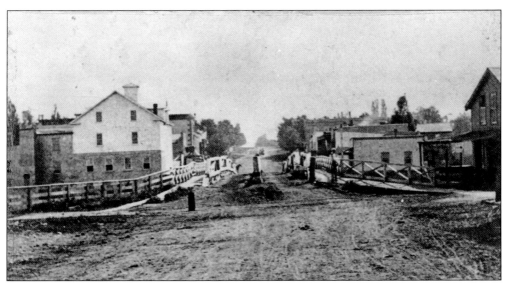

In October of 1874, the town was incorporated as the current City of St. Charles. The first officers were elected in 1875, and Dr. James K. Lewis was the first mayor.

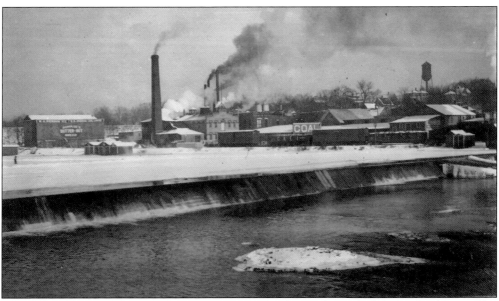

A number of large factories operated in St. Charles during the end of the 19th century. This photograph was taken from the west side of the bridge, capturing the northeast side. The National Milk Sugar Company and the St. Charles Condensing Company were located at the center of this photograph. The milk factory opened in 1889 employing one hundred people. The plant was developed by Lorenzo Ward on North First Avenue. Also visible is the train along the river, which brought in coal and lumber for the operational needs of these businesses.

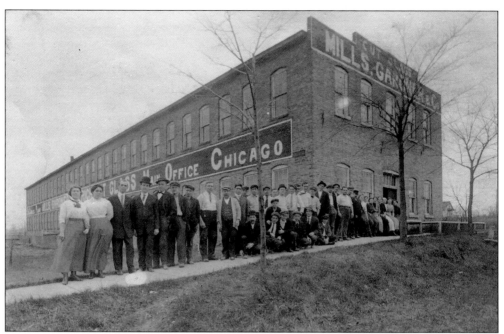

The Heinz Brothers Cut Glass Company moved from Chicago to St. Charles in 1905. The factory was one of a number of new, large businesses that arrived in town between 1900 and 1905, including producers of musical instruments and textiles.

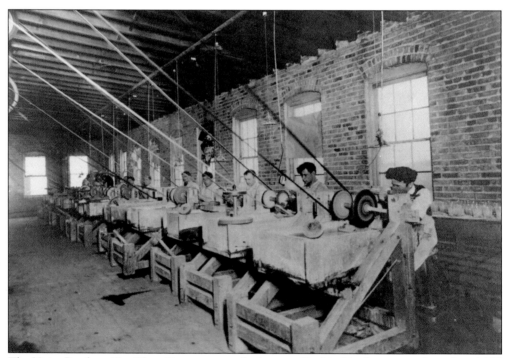

The Heinz Brothers Cut Glass Company was the largest of its kind in the west and employed 100 workers. The Heinz brothers (Richard, Emil, and Otto) came from Germany and operated the factory until 1925. They were noted for their attention to detail and superior craftsmanship.

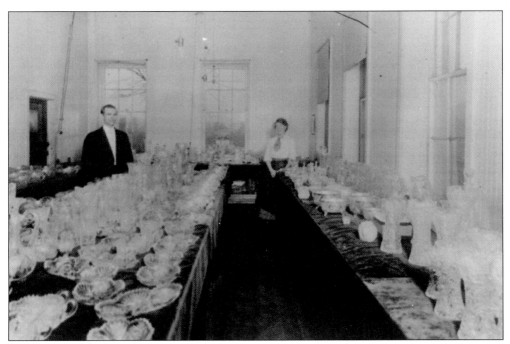

The glass company was known worldwide, as it exported 600 varieties of elegant cut-glass vases and tableware. This was a period when cut glass enjoyed a tremendous popularity. The company took advantage of the fad by introducing a large show room in town that included items not perfected following the production process. These slightly defective pieces were sold cheaply to the locals.

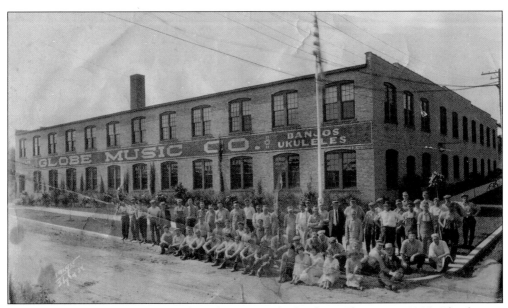

The Globe Music Company was brought to St. Charles from Chicago in 1915. The factory, under the leadership of Frank R. Johnson, initially employed about 65 employees, and at its peak had 125 workers. Guitars, banjos, and ukuleles were constructed at the site at Eleventh Avenue north of Main Street. The company produced 250,000 instruments annually.

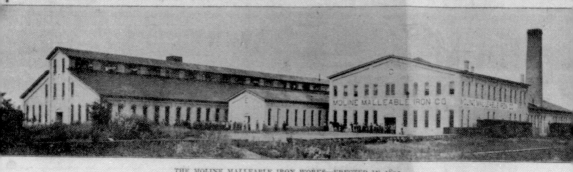

The Moline Malleable Iron Factory moved to St. Charles in 1893 following its establishment in Moline, Illinois in 1869. The factory produced malleable castings and detachable and riveted chains. In 1915, the plant was destroyed by fire, but the company quickly rebuilt a new state-of-the-art facility.

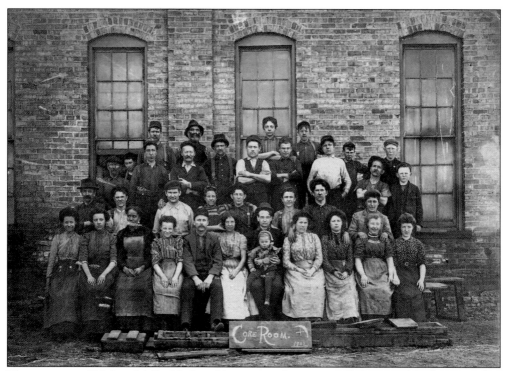

The majority of Moline Malleable Iron Factory employees were Belgian and had migrated to the United States in the mid 1800s following a land shortage in their homeland. Most moved with the company after its relocation from Moline, Illinois. Over 100 Belgian families resided in the community, creating a section that was called "Belgium Town." Since they were Catholic, the Belgian colony quickly infused new life into the small and struggling parish of St. Patrick's. This 1902 factory photograph shows women and young adults already part of the industrial work force.

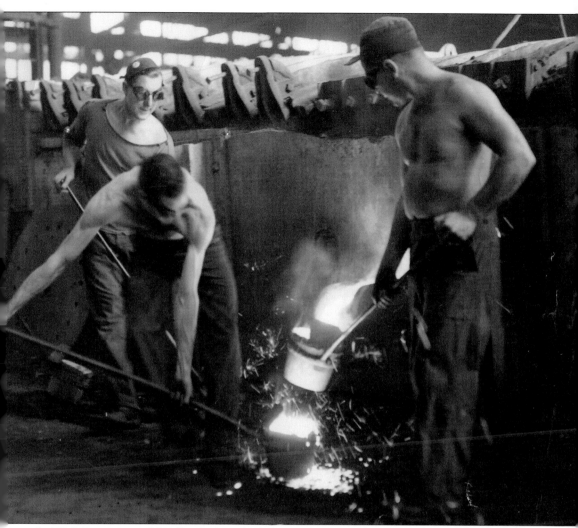

A 1926 Community Handbook described the working conditions at the rebuilt factory in this manner: "It is, perhaps, the brightest lighted foundry in the world, having a glazed area of 50,000 sq. ft., or 70 percent of the walled area. Good light in a foundry, while unusual, is very essential in producing clean molds and for rigid inspection of the finished casting. Heat and ventilation, aided by construction and height of the roof, are under control of a modern blower system supplemented by swinging steel window sashes. Working conditions are, naturally, excellent."

While the Belgians comprised the majority of workers at the iron factory, the Cable Piano Factory, which had moved to St. Charles from Chicago in 1901, occupied a large number of the rapidly arriving Swedish immigrants. The company operated another factory in Chicago, and in 1899, the management identified the St. Charles location in order to meet the increased production demand. This was one of the largest piano makers in the world with dealers in Spain, Italy, Japan, and Australia. The factory produced fine quality pianos and accessories, at the rate of 35 units per day, until 1937.

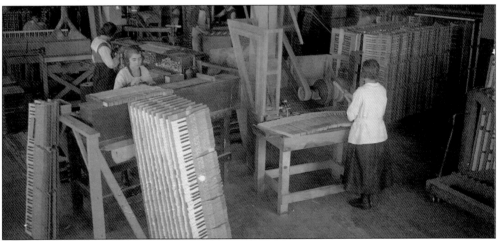

Local civic and business elites viewed the selection of St. Charles as a site for this expanding company as a reflection of the city's developing atttraction. Town beauty and convenience were mentioned as the key considerations. The piano factory was located at the southwest part of the community next to the river, and it employed 500 workers. A local publication boasted that, "The majority of the employees, including most of the foremen and many of the factory officials live in St. Charles. The general superintendent of the two Cable factories and the general superintendent of the St. Charles factory make their homes here."

During the early years, the sole bank was located under the hall in the Minard Building and was known as the Banking House of J.C. Baird & Co. In 1887, the bank was robbed and $5,000 was stolen. Soon, additional banks appeared as the St. Charles Building and Loan Association was organized in 1891, and the St. Charles National Bank opened in 1902 at 107 West Main Street.

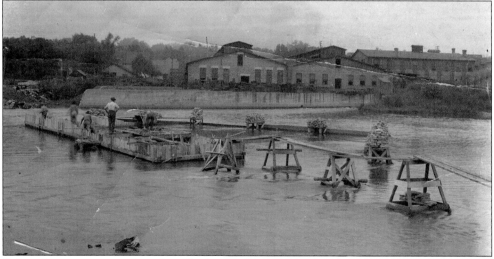

Other factories operated in St. Charles at the turn of the century, including the Glenn Manufacturing Company (pictured in the background) and the St. Charles Net and Hammock Company, which was organized in 1906. Glenn Manufacturing, established in the 1860s, was located at the southwest part of town on a three-acre tract along the river. Operated by waterpower, it produced plumbing supplies and jobbing castings. This photograph shows the construction of a footbridge across from the factory. The bridge allowed workers to travel across the river for work, some going to the Cable Piano Factory.

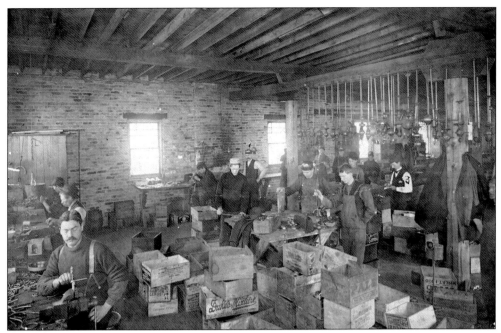

The St. Charles Fixture Manufacturing Company produced chandeliers. Founded in 1908, the company located in a large building on the east side of town (the current site of the Municipal Building). "High Quality Exclusively" was the slogan, and the fixtures it produced were used at the Henry Rockwell Baker Community Center, the National Bank Building, and the St. Charles Country Club.

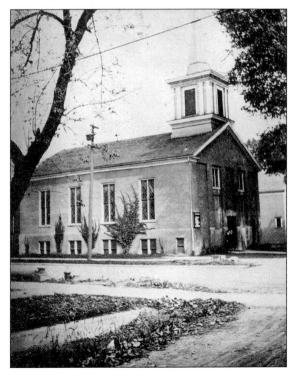

The Congregational Church on Walnut and Third Streets was built in November of 1848 and is the oldest church building in St. Charles. The congregation was organized in 1837. For the first few years, Father Clark met for worship with a small group in private homes. In 1842, preparations were made to build, and Darwin and Miranda Millington donated the land. During construction, work began with the digging out of solid rock in the basement. This was so costly that they had to temporarily put a roof over the basement and use it for services until they could raise the money to finish the building.

Old St. Patrick's Catholic Church also began with the congregation first meeting in private homes. In 1843, Father Keegan began saying Mass in the house of Michael Flannery. The limestone for the construction of a building, under the supervision of contractor Seth Marvin, came from a nearby quarry on Dean and Third Streets (the current location of the VFW). The Old St. Patrick Church was completed in 1851. The parish grew very slowly in the early years, but the relocation of the Moline Malleable Iron Factory in St. Charles (1893) signaled the arrival of Belgian and other Catholic immigrants. By the turn of the century, more than 100 families attended the Church.

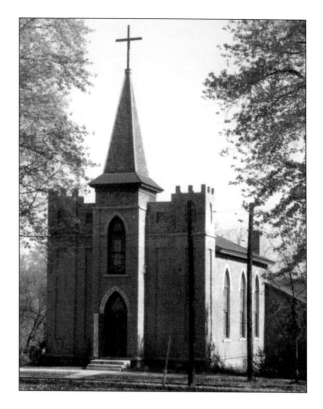

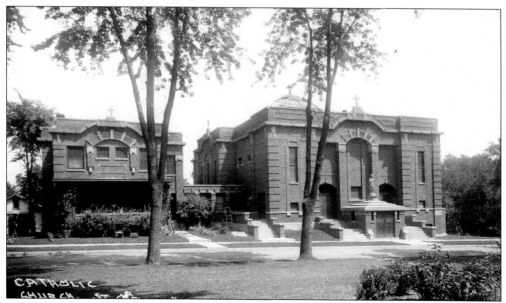

Father Robert Carse took over St. Patrick's Parish in 1909, and from 1911 to 1912, he facilitated the construction of a new domed church at 408 Cedar Street. The new church was considered too large at that time, and Father Carse was sharply criticized for introducing a facility perceived rather sizable for the needs of the parishioners. But the parish continued to expand with the town, and the new structure was well-utilized.

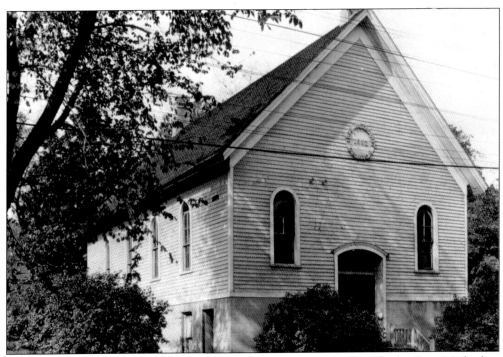

On the southwest corner of Walnut and Seventh Avenues, the St. Charles Free Methodists dedicated a church in 1861. The congregation remained on Seventh Avenue until 1882. Members eventually erected a new building on the southwest corner of Walnut and Third Streets. Members brought rocks from the banks of Ferson Creek for the construction of the foundation.

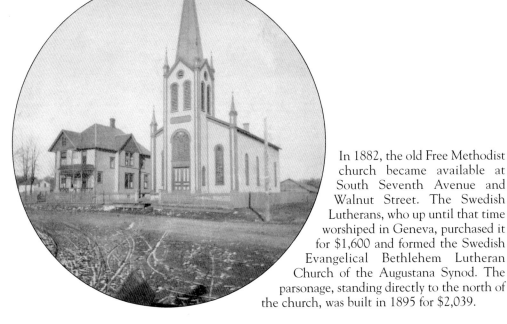

In 1882, the old Free Methodist church became available at South Seventh Avenue and Walnut Street. The Swedish Lutherans, who up until that time worshiped in Geneva, purchased it for $1,600 and formed the Swedish Evangelical Bethlehem Lutheran Church of the Augustana Synod. The parsonage, standing directly to the north of the church, was built in 1895 for $2,039.

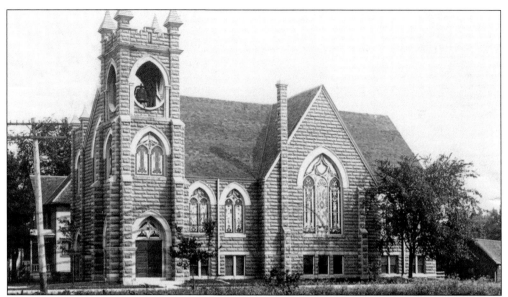

In 1905, the Swedish Lutherans built a church at the cost of $7,900 after outgrowing the previous building. At that time, the church services were conducted entirely in Swedish. In 1919, it was decided that services would be held in English every other Sunday.

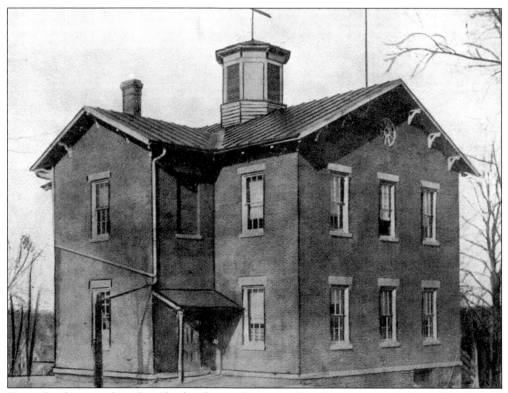

Two schools existed in St. Charles during this time. On the east was the East Side School (1856–1928), where Frank Rockwell served as principal. On the west side, under the leadership of John Raymond, stood the West Side School (1854–1930), which is shown here.

According to the 1885 city directory, there were 423 children in town. The existing school districts 8 and 7 were united to form District 87 in 1897. Charles E. Mann was the first superintendent, and in 1898, a new high school was built for $30,000 on land donated by Charles Haines on East Main Street. The building later served as a junior high school.

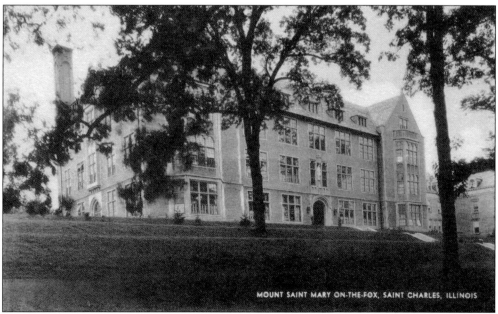

Mount Saint Mary Academy on the Fox opened in 1907; it was a Catholic high school for girls. The school grounds were located at the old Farnsworth estate in the southwest part of the city. The land was bought by the sisters of the Dominican Order of Adrian, Michigan, which started the school. The enrollment was about 125, including approximately 90 students who lived on campus as boarders.

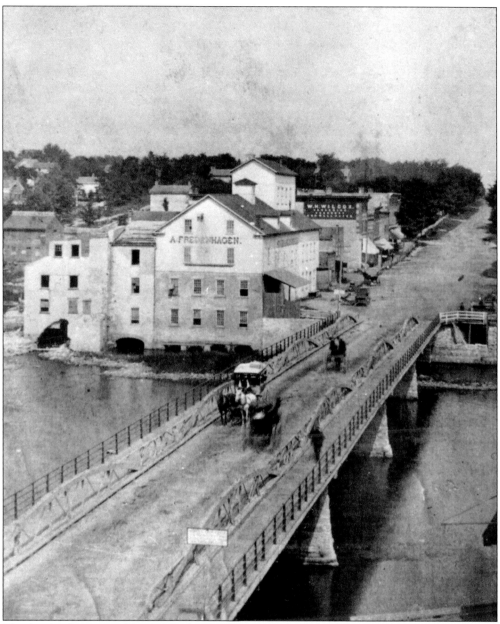

The first bridge across the river, built in 1836, was 18 feet in width. Following an ice storm and a great flood, the bridge was completely destroyed in 1849. Ferry service provided continued transportation across the river. The bridge in this 1885 photograph looking east was constructed in 1874 for $8,400. The Fredenhagen Mill on the north side of the street, located at the current site of the Municipal Building, was purchased by Adolph Fredenhagen in 1877.

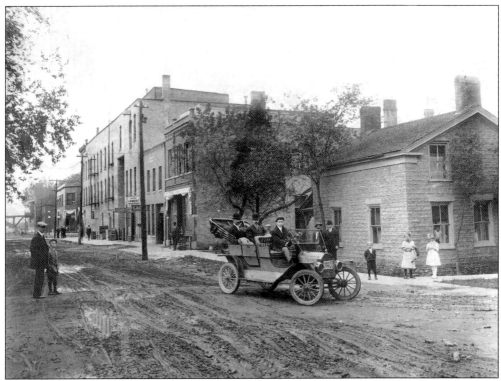

This photograph of South Second Street was taken in 1908 and shows the partners of Crown Electrical Manufacturing Company, Mosedale and Horne, driving around town. The car is turning eastbound onto Walnut Street. The small building behind the car is the current location of the St. Charles National Bank. Crown Electrical first located in St. Charles in 1892, initially producing gas lighting fixtures. Later, the company manufactured electrical lighting fixtures including floor, bridge, table, and boudoir lamps. Crown Electrical supplied Hotel Stevens in Chicago (at that time, the world's largest hotel) with 5,500 lamps.

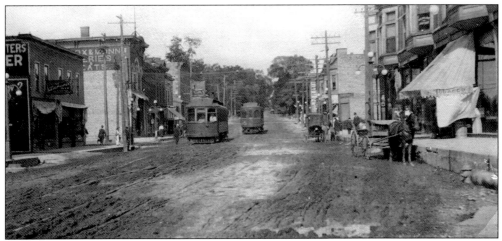

This photograph was taken in the summer of 1915 and provides a view looking east right at the edge of the bridge. First Avenue is the first visible street; trolleys and horse drawn carriages dominated the streetscape.

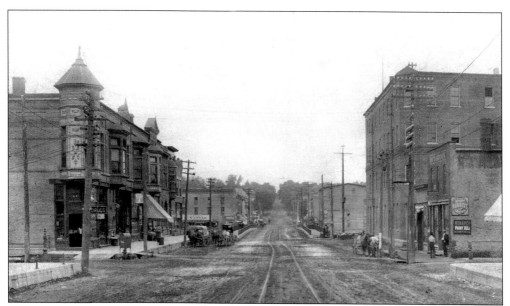

This photograph from First Avenue looks west across the bridge. A number of businesses are visible on the south side of Main Street, including a drug store and an ice cream parlor. On the north side, the current sites of Hotel Baker and of the Municipal Building can also be identified. Those two lots on either side of the river proved to be key locations for many businesses over the years.

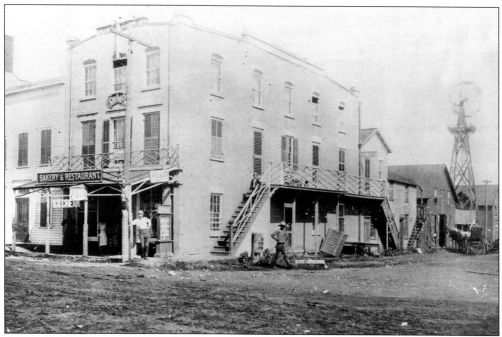

Gartner Bakery at Second Street (Rt. 31) and Main Street relied on the popularity of ice cream at the turn of the century. Joseph Gartner, a German immigrant, opened a bakery and restaurant in 1890 in the old Dearborn Building and was widely known for his 5-cent ice cream dish and 25-cent Sunday chicken dinner. Joseph's brother John opened another bakery in 1893 on East Main Street.

25

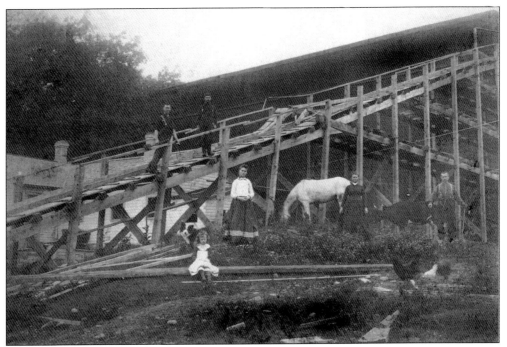

Ice was a commodity, and harvesting it from the river was a business. Two icehouses operated in town in the late 1800s, one on each side of the river. The McBride Brothers operated the west side business and sold the ice for refrigeration.

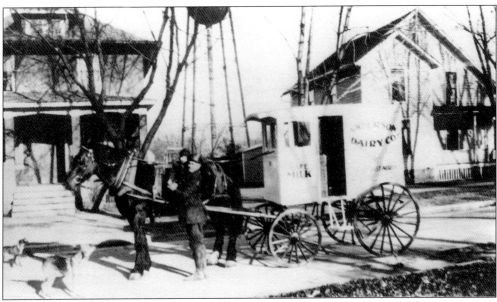

The St. Charles Pure Milk Company, initially located on the west side, provided dairy to the locals and was operated by Simon Anderson and family who were of Swedish origin. Local farmers daily provided bulk milk, and the subsequent milk delivery ensured fresh products to families in town. In 1910, Simon Anderson expanded his business and began producing ice cream. This family business eventually evolved into Anderson Dairy Co. and then Colonial Ice Cream, Inc.

This was the site of the first store in town built by Ira Minard at the northeast corner of Main and First Avenue. The original, two-story wooden structure was constructed of lumber brought from Batavia. The general store opened in 1836 and served as a center of services and a hub of social interaction. This photograph shows the entrance of the Wilcox and Munn Grocery Store, another commercial enterprise in that location. Fresh produce on the sidewalk included turkeys hanging from the rope. Note the height of the sidewalk relative to the street. The city hall building is visible on the west side of First Avenue.

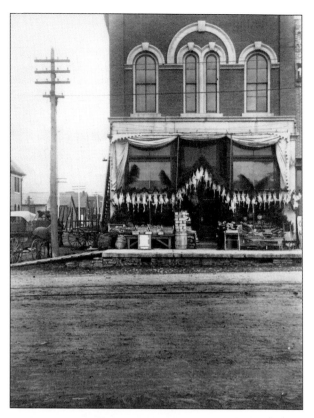

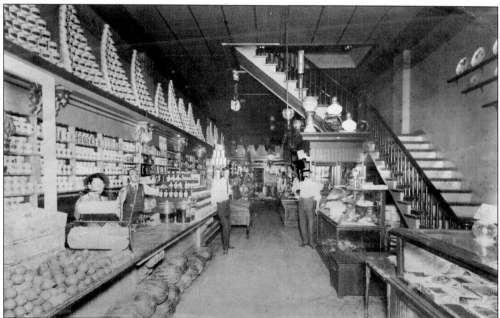

The Wilcox and Munn Grocery Store was also well-equipped as watermelons, lemons, oranges, and a plethora of canned foods were available to its customers. Cases with cigars and other tobacco products are visible on the right of this photograph.

John Fabian Colson established a dry goods store on west main, east of Second Street, in 1880. Colson came to St. Charles from Sweden in 1853, and following a partnership with Charles Anderson, expanded the business. The photograph depicts a sidewalk sale in front of Colson's.

Colson's proved to be a main supplier of clothes for residents, and the store persisted for over a century. Sensitive to the local immigrant population, Colson's always employed bilingual employees to better serve the Belgian, Swedish and Lithuanian residents. The store was considered one of the main family enterprises in St. Charles.

Two

INFRASTRUCTURE AND CIVIC CULTURE 1880–1920

The development of civic culture and infrastructure in St. Charles followed numerous technological advancements. It also complemented the recent growth in business and population. Telephones, newspapers, rail and streetcar service, street lighting, water mains, gas lines, and an expanded postal service all took place during that time. Furthermore, a new library building was introduced, and community organizations sprung up across town.

Philanthropists like Charles Haines proved important figures in the development of St. Charles at the turn of the century. His family owned the old Millington Mill, founded in 1842, where they butchered hogs. The mill was located on the west side, occupying what would later become the Hotel Baker complex. As an only child, he was the sole inheritor of the family's wealth. Though never married and without children, Haines was deeply committed to the educational advancement of the community. In addition to numerous community contributions and service during his lifetime, at his death Haines left $100,000 and land in a trust for the advancement of the local educational system.

During that period, all six mayors addressed key needs for services that would eventually ease everyday living. In response to the growing number of suspected arson fires, Mayor Fred E. Glenn (1905–1907) authorized rewards of $100 to anyone providing information leading to the arrest and conviction of individuals detected setting a fire to any building within the corporate limits of St. Charles. A few years earlier, Mayor Charles H. Haines (1889–1991) was authorized to offer a $500 reward for the apprehension of the person who caused the burning of the Bignall Hardware Company.

At this time, St. Charles began to emerge as a destination spot for Chicagoans endeavoring to escape the pressures of urban life. The attraction to the clean shores of the Fox River added another flavor to local life.

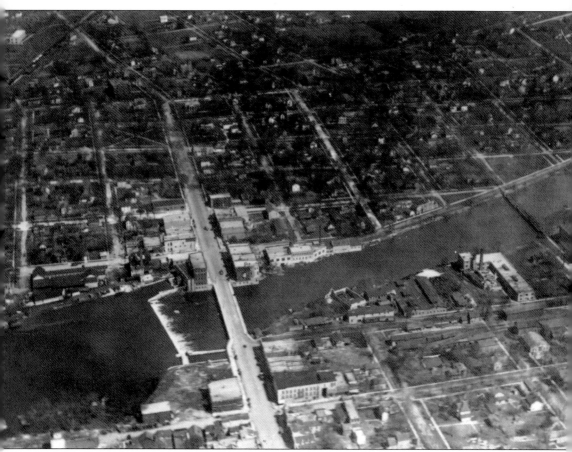

This aerial photograph of St. Charles was taken in the early part of the 20th century, prior to the construction of Hotel Baker and Arcada Theater (both empty lots). The Carnegie Library and the Charles Haines School are visible at the top of the hill on the east side.

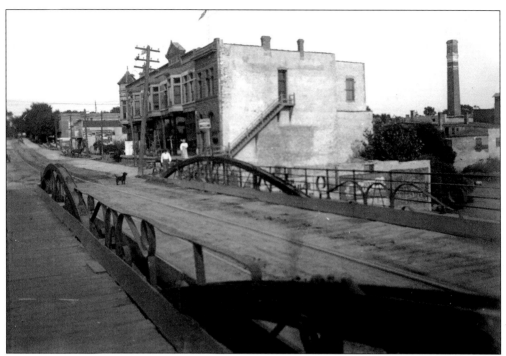

The bridge was the most important avenue of transportation and communication in town. This photograph was taken in the late 1880s and captures the southeast part. Alice Davis (1940) describes the structure, "The bridge had railings at its outer edges and also at its inner edges of the board sidewalk to protect pedestrians from the frisky horses that often ran away. The old iron bridge rattled and shook as the lumber wagons, gigs, and surreys tore over it."

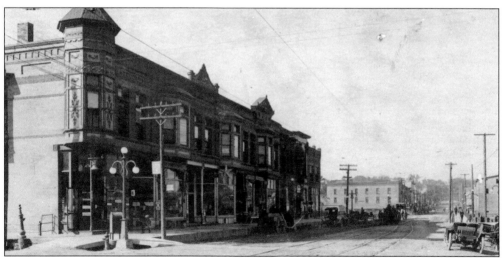

This photograph of the south side of East Main Street shows the transition of transportation from the horse and buggy era to the automobile. The trolley tracks with the electric cable above are also visible. Taken around 1910, the image also depicts a number of businesses including Harman Longacre Druggist at 47 East Main Street. A 1910 ad in the city directory identified some of store's products: "Dr. Yerke's Cough Syrup, French Opera Rouge, M. Esstelle Gilbert's Massage Cream and Skin Food, Cold Creams, Liver Pills, Antiseptic Oil."

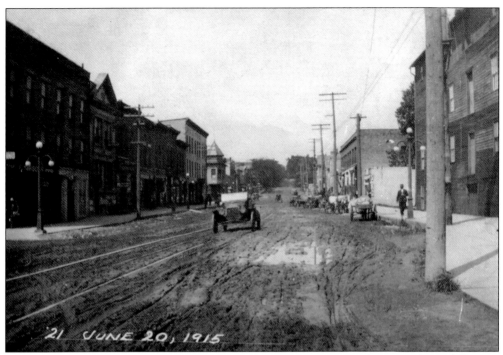

This June 1915 photograph of Main Street, prior to its paving, reveals its condition following a summer rain. The car in the picture struggles to make it across the west side as deep mud covers the area. All other streets remained dirt roads and during dry spells, clouds of dust were visible across town.

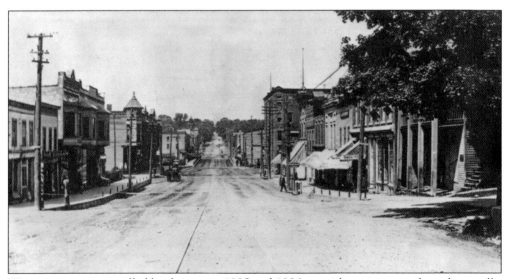

Water mains were installed by the city in 1905 and 1906, providing city water from deep wells, a project that eliminated the old pumps. Another deep well was dug in 1914 and was 2,300 feet deep. During that period, the St. Charles Park Commission requested that the City provide drinking water free of charge to the public at Pottawatomie Park. As an extension, the Ladies St. Charles Cemetery Association asked that a water line be extended to the cemetery and a drinking fountain be provided and maintained at city expense.

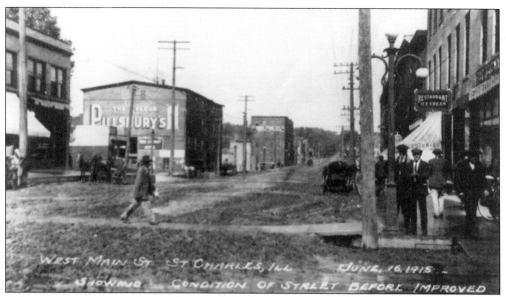

Pedestrian crossing was also a substantial challenge during summer rains. As this photograph reveals, the city placed wooden planks across Second and Main Streets to ease passage. The bridge is visible in the middle of this photograph, as is the St. Charles Fixture Company building (the current site of the Municipal Building). Note the height of the mud next to the sidewalk.

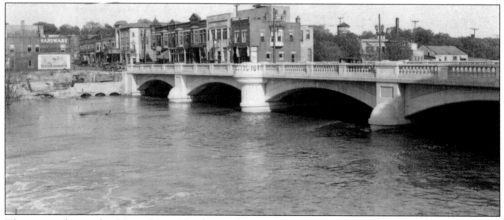

This view shows the Main Street Bridge and its improved structure, c. 1930. The semi-circular extension visible in the middle of the photograph would later feature gazebos that aimed to beautify the setting as well as slow down automobile traffic.

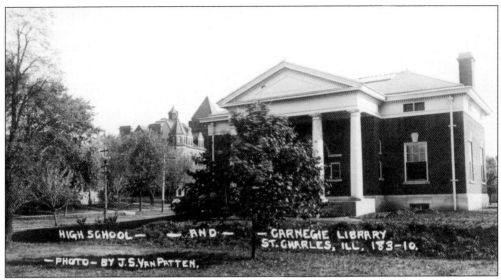

Founded in 1889, the St. Charles Library was housed on East Main Street. Members paid $2.00 a year for books, and Jennie Lewis served as the librarian. Numerous churches also maintained small libraries during this period. The Carnegie Library was built at Fifth Avenue and Main Street in 1908 after a vote in 1907 approving bonds for a public library. The Carnegie Library Fund donated $12,500 toward the construction of the building (total cost of $15,000). Controversy emerged regarding the east side location as west side residents felt it was not centrally located. In 1926, the library holdings reached 8,721 volumes. The Haines School is visible on the left.

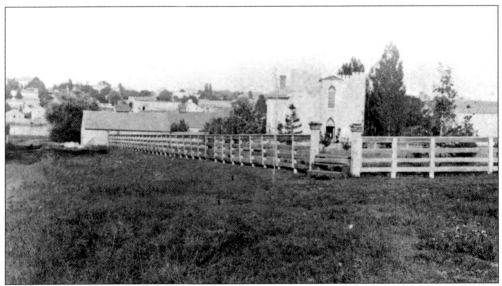

There were two parks in town—one on the east side and another on the west side. Darwin Millington donated the park on the west side and Ira Minard, Dean Ferson, and Calvin Ward contributed the block on the east side for the park. This photograph was taken in 1872 of the West Side Park (now Lincoln Park). Note the fence intended to keep animals, in particular cattle, from entering the park space. During that time, the steeple had not yet been installed at St. Patrick's Church, visible in the background.

The old Dearborn Building (replaced later with the St. Charles National Bank) was located at the northwest corner of Second and Main Streets. The Masonic Hall occupied the third floor, serving various social needs of the residents. Irwin Hall stood across the street, at the southeast corner of Second and Main Streets. It was named for William C. Irwin, a mason and a carpenter who owned the building, and began to draw visitors in 1890.

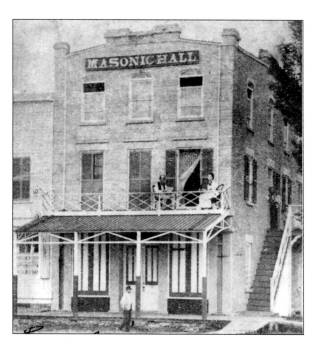

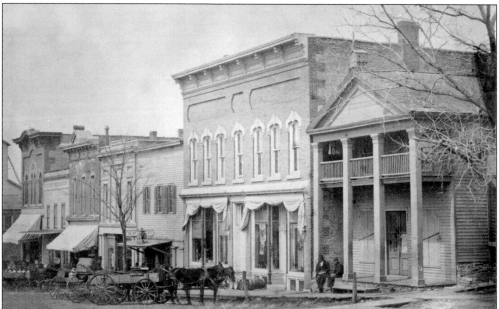

This block of buildings was located on the northeast side, across from Arcada Theater on Main Street. The Strand Theater, on the far right in the photograph, and Minard Hall, on the southeast corner of Second Avenue and Main Street, are visible. Over the years, these served as town centers for plays, concerts, and religious activities. According to Alice Davis (1940): "Activities here surely went from the sublime to the ridiculous. The hall was the entertainment center where Charlotte Powers put on her home talent plays, where negro minstrels were held, where politicians thundered out their orations, where small companies gave tragedies and comedies. The colored people had their own Baptist Church which held services in this hall, doing their immersing in the river."

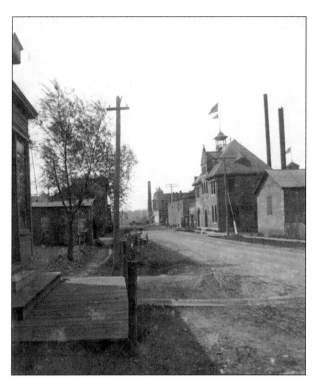

This view from the north shows the St. Charles City Hall, built in 1892 on First Avenue. That year also signaled infrastructural changes. Up until that point, lampposts with oil lamps were scattered throughout the town, but following an ordinance passed by the city council, a dynamo was purchased to furnish electric power for lighting the streets. Waterpower was also purchased from the Butler Paper Company to provide lighting across the town, including the city hall and the fire engine house. The city electrician was notified to put meters in all homes where electric light was used, setting the minimum rate per meter at $1.50 per month.

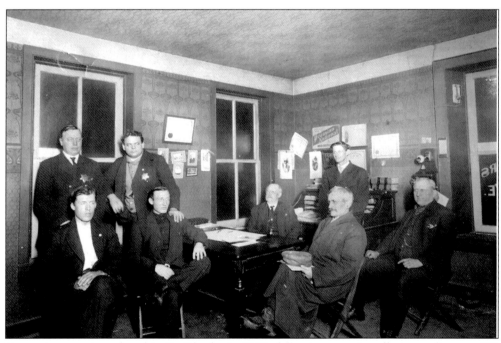

Gas mains were introduced in St. Charles in 1901, following a gas installation ordinance. Oil stove and kitchen ranges were replaced by gas stoves. This photograph of local officials was likely taken in Mayor Edwin M. Hunt's law office (seated at the far left). It includes members of the St. Charles Police and Fire Departments.

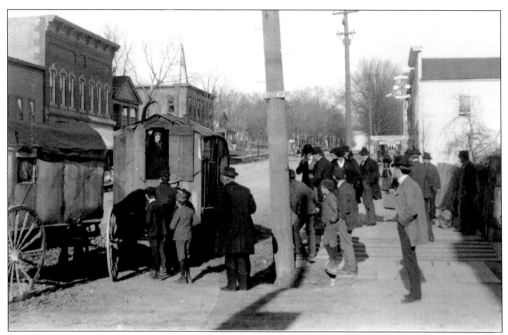

In 1885, a stage line was established between St. Charles and Geneva carrying mail and passengers. The fare was 25 cents, and Charley Thompson drove the stage. The stop was on the east side of First Avenue. Note the empty lot on the right, future site of the Arcada Theater.

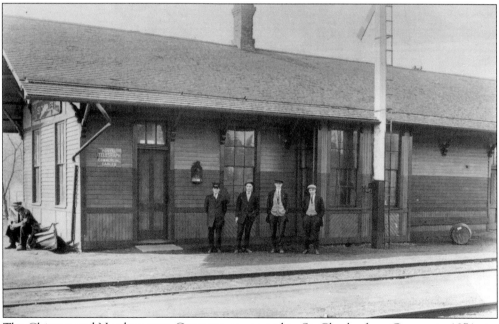

The Chicago and Northwestern Company connected to St. Charles from Geneva in 1871 at a cost of $45,000. The railroad connection was secured by General John Farnsworth and O.M. Butler. The Northwestern R.R. station was on the corner of West Illinois and First Streets. The station agent lived in the building with his family. The cost to go to Chicago in 1890 was $1.07. In 1886, the Chicago Great Western Railroad was able to add a line into St. Charles.

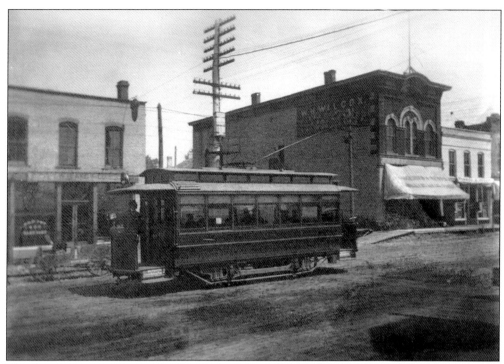

The first street car comes to St. Charles in July of 1896, following the city's 1895 decision to grant permission to the Aurora & Elgin. These streetcars operated until the 1930s.

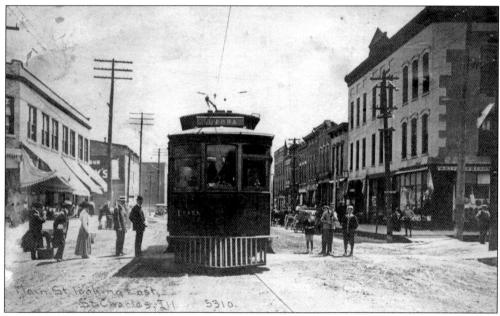

The Chicago, Aurora, Elgin third-rail electric line was introduced in 1910. The franchise paid $1,000 a year for the right to operate the line.

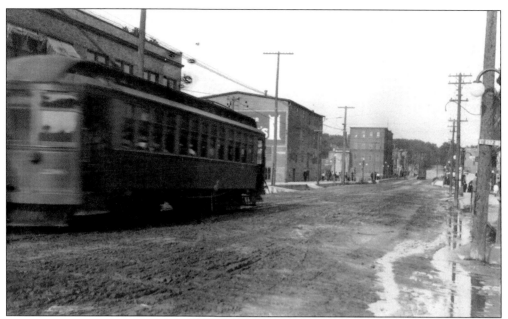

By 1913, cars ran hourly. This was the most direct way to get to Chicago. In the 1920s, Route 64 came to the area, helping revitalize St. Charles.

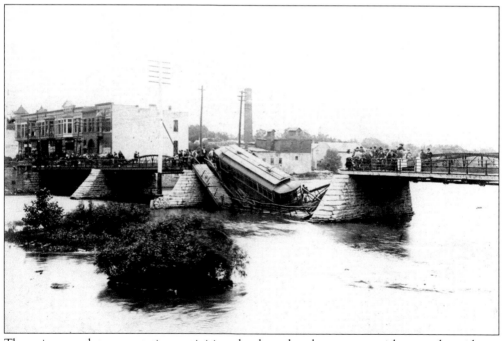

These increased transportation activities also brought about some mishaps and accidents. On July 1, 1902, a streetcar broke the bridge, forcing residents to cross the river by boat for a few days. The car was moving slowly, so there were few injuries among the 30 passengers and minimal damage to the car.

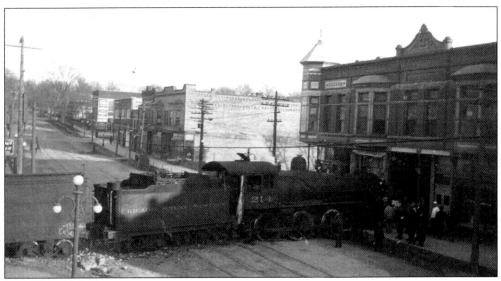

In 1915, a Great Western Railroad engine was derailed at North First Avenue, falling into the southern part of Main Street and Sapperstein's Clothing Store.

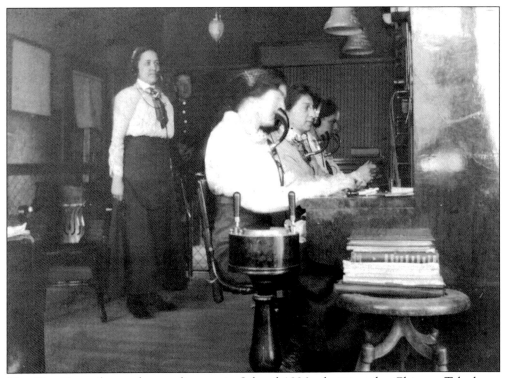

The City Council passed an ordinance in July of 1886 admitting the Chicago Telephone Company. The company was given permission to use the streets and alleys. An exchange office was operated on Main Street. By 1913, the city had 680 telephones with long distance service to Chicago and DeKalb.

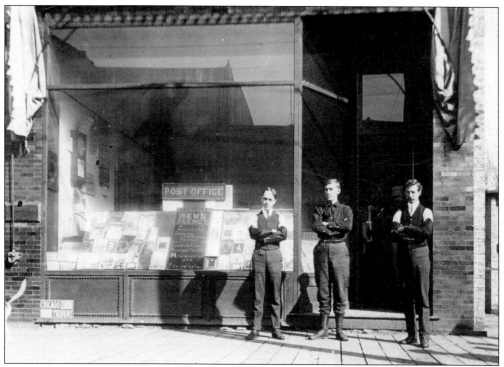

The Post office was on East Main Street between First and Second Avenues (south side). In 1890, E.A. Brownell served as the postmaster. The office also doubled as a news agency. In 1881, a weekly newspaper called the *Valley Chronicle* was introduced; it was later renamed *The St. Charles Chronicle*.

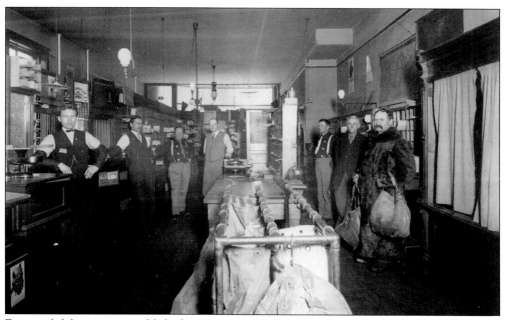

Free mail delivery was established in 1904. Two deliveries daily were made in residential areas and four in the business districts.

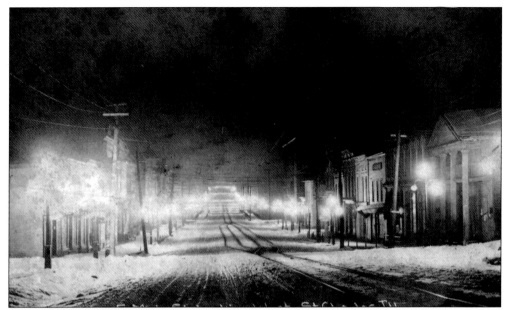

Lighting the streets proved a very important change for life in St. Charles. During the mayoral term of Fred E. Glenn (1905–1907), West Main Street merchants were granted permission to light the streets from December 16th to December 25th. The Swedish Lutheran Church asked for extended electric wires for operating an organ motor.

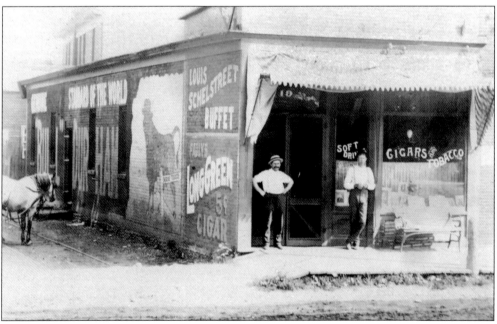

Located at 19 East Main, this was a popular tavern during the early 1900s (currently a parking lot at the Municipal Building). Louis Schelstreet served a buffet lunch, drawing patrons from the St. Charles Fixture Co., which was located across the street to the east. An unidentified man stands next to Louis, who is at the left. The railroad tracks leading to the factories on the east side of the river are also visible at the side of the building.

This 1880s photograph shows the C.A. Stewart Undertaking Shop on East Main Street. The second floor housed a furniture store. A horse and a wagon are visible in the front.

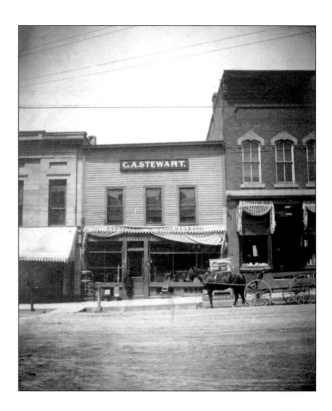

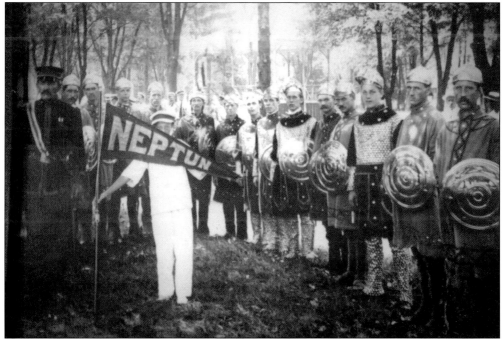

Many social organizations formed in St. Charles during this period. Members of the Neptune Lodge #35 met in Irwin Hall on the west side in the early 1900s and posed for this photograph in Lincoln Park. Their membership hovered around 125 individuals.

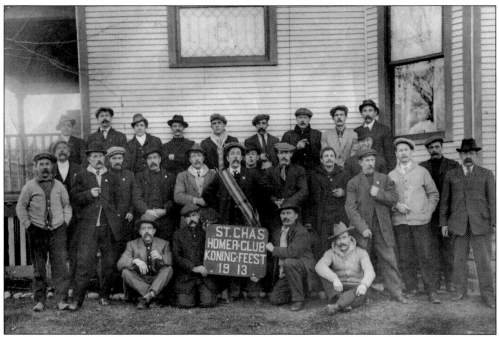

The St. Charles Homer Club was also very popular in town. Comprised primarily of Belgians, the club entered races for young birds and old birds in May and August.

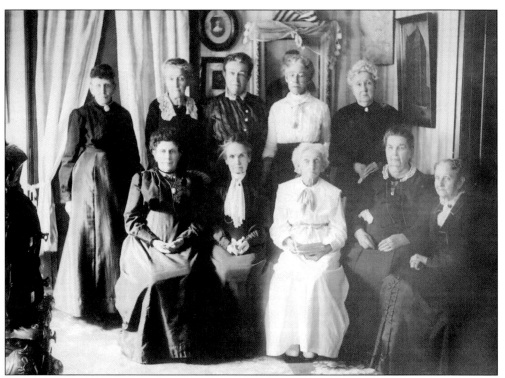

The Jolly Sixties Club was organized in St. Charles in the late 1800s. This photograph includes some of the members who were part of the social elite of that time.

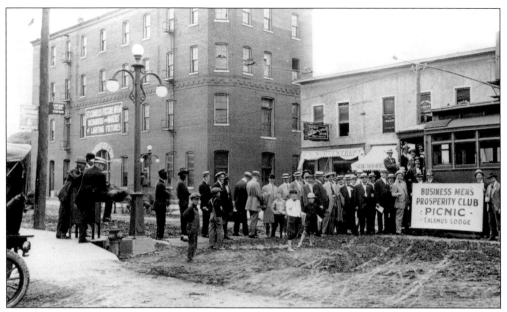

The Business Men's Prosperity Club gathers on the east side (First Avenue and Main Street) as depicted in this early 1900s photograph. The Schelstreet Tavern and Hunt Brothers Loans are visible in the background, as is the St. Charles Fixture Manufacturing Co. at the left.

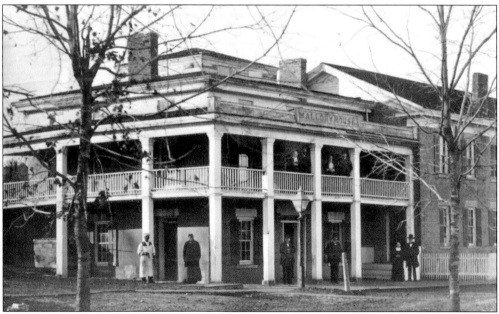

Hotels have a long history in St. Charles. The Mallory House was established in the early 1880s following many years as the Howard House (opened in 1848). The Howard House was developed by Leonard Howard, a craftsman mason known for his work in Chicago. The distinctive columns were added during that time. Mary Todd Lincoln stayed at the hotel, registered as "Mrs. May," following the assassination of her husband. The Mallory House was listed in the 1885 directory as ". . . widely known, particularly in Chicago." In 1891, the hotel fell on hard times and was put up for rent. It stood at the northwest corner of Third and Illinois Streets.

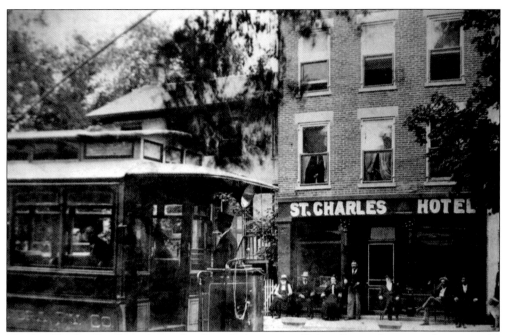

The St. Charles Hotel was located at Fourth Avenue and Main Street. It operated a successful restaurant in the early part of the century until 1910. The hotel eventually was replaced by the Illinois Cleaners and Dyers building.

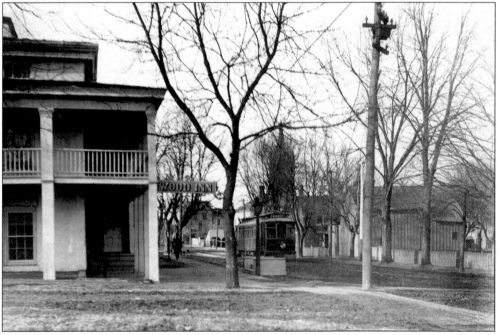

In the early 1900s, the old Howard-Mallory House reopened as the Atwood Inn. The inn was a center of social events for various local organizations, which held many of their gatherings at the building. The Atwood did not survive, as other hotels like the White Front and Hotel Baker provided stiff competition. The inn was eventually converted into a clothing factory.

Three

TOURISM, SPORTS, AND LEISURE

St. Charles advanced as a town of tourism, culture, and leisure in the early part of the 20th century as the community was discovered by Chicago residents, who found the river and its entertainment possibilities very attractive. A number of summer colonies could be found along the shores of the Fox River north of the bridge. By the 1920s, St. Charles was a recognizable vacation spot, and several large-scale, entertainment-oriented construction projects like the Arcada Theater, Hotel Baker, and Pottawatomie Park, provided the needed infrastructure to propel the town's image.

These developments and their potential implications for the future growth of the city were quickly recognized by local boosters. In a 1926 Community Handbook, St. Charles was introduced by the Chamber of Commerce as "The Beauty Spot of the Fox River Valley." While the handbook referenced the rising businesses stock, it also described with great pride the multitude of cultural amenities and natural beauty.

Forrest Crissey, a local writer who moved to the Fox Valley from New England in the late 1890s, described his first impressions of the area: "The thrill which came to me with my first view of the Fox River Valley made an imperishable impression upon me. It seemed almost unbelievably varied and verdant for a landscape in the rich prairie country of the Middle West—as if, when God made New England, a generous portion of that material had been left over and placed in Northern Illinois. . . . The enduring quality of enchantment which this valley casts upon those who have eyes to see its beauty is the supreme test which can be imposed upon any place, any landscape, any person."

The Wallace Evans game farm was one of the largest in the country and was located in the northwest part of town. Lester B. Colby, a member of the Illinois Chamber of Commerce noted: "Out in the hinterland beyond St. Charles we find the Wallace Evans game farm. Here dear roam the hills, swans swim in little lakes and wood ducks and mallards and canvasbacks preen in the watercourses. Peacocks spread their fans and pheasants, gaily colored, march in the enclosures."

Sporting activities were also common forms of entertainment in town, especially at the high school level, and included football, basketball, and baseball. In addition, the Belgian-American Football League, city championship competitions in basketball and other sports, and motor racing outside the city brought residents together throughout the year. Finally, the river and the ice afforded numerous entertainment opportunities as summer and winter games and activities gained in popularity.

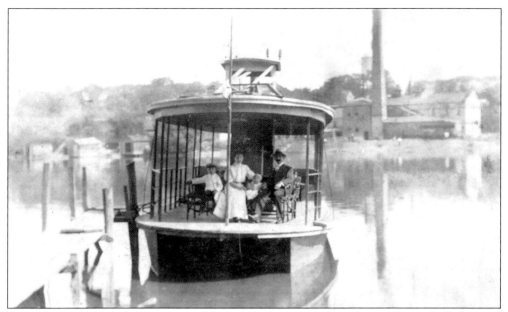

Minard's Hall (Second Avenue and Main Street) on the east side and Irwin Hall (Second Street and Main Street) on the west side served as the social centers of town. Dancing and stage performances were very common, and many of these activities would extend into the late hours. At the same time, the river offered an abundance of activities; boating was one of them, as this 1906 photograph of a family aboard the S.S. *Pacific* shows.

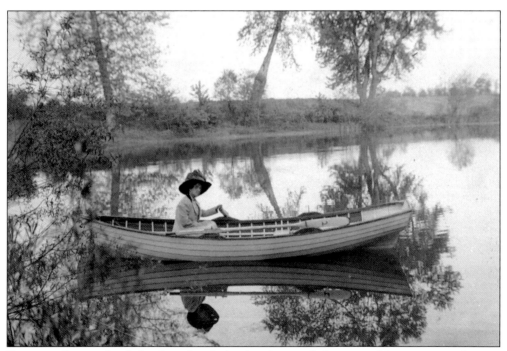

For ten miles north of the dam, bends in the river and the natural beauty created many attractive camps. The riverbanks were clean and sloped back into large open spaces of grass, creating fields with small summer homes and large country estates.

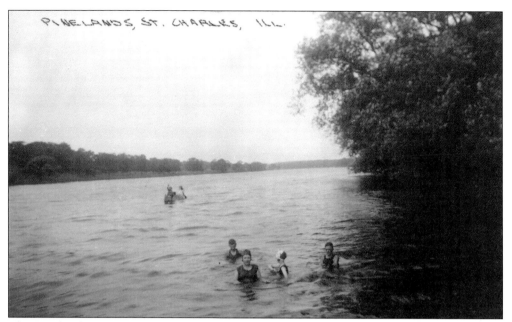

The Pinelands was a resort area located north of Main Street, on the east side of the river. It included numerous cottages and was known to many of the summer visitors for the dance music, clear water, and excellent outdoor environment.

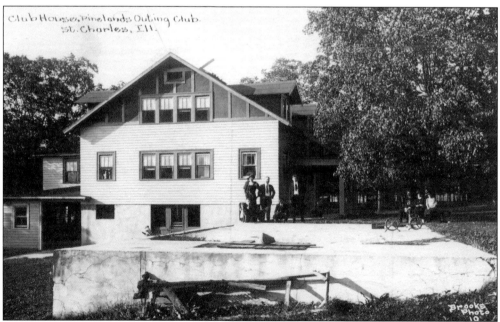

In 1908, Claus Alfred Anderson of St. Charles, a carpenter and noted builder, acquired the Pinelands. Within a few years, many homes were built in the area, most owned by Anderson. In 1911, four members of the Chicago Chloral Club from the settlement house on Grand Avenue came to Pinelands to rent a place for the summer. Anderson had just built a barn, which the group rented and converted into a clubhouse.

Anderson constructed the Pineland Dance Hall shown in this photograph. The facility became a Mecca for dance lovers, and big name orchestras such as Wayne King, Vincent Lopez, and Paul Whiteman played there.

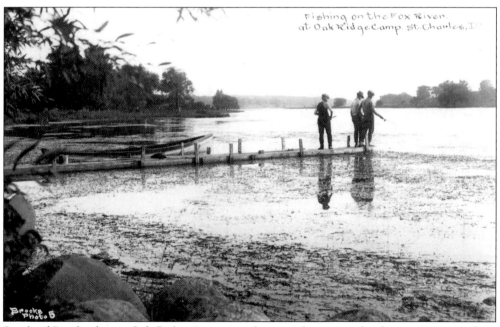

South of Pinelands was Oak Ridge Camp, another popular resort. Outdoor activities such as fishing were widely advertised along the communities of the Fox River, as well as in Chicago.

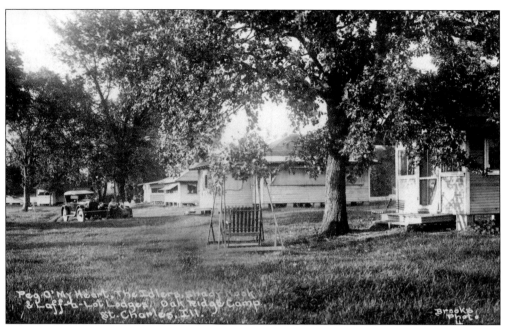

Most of the cottages were occupied by weekend visitors, and the camp developed a reputation for Chicagoans looking to escape the pressures and daily challenges of urban life.

Oak Ridge Camp was a seasonal resort opening in early May. The leasing of cottages for the summer months typically began in the spring, and a band would be reserved by the management for the entire summer. The rolling hills and open spaces next to the river afforded numerous opportunities for popular family activities.

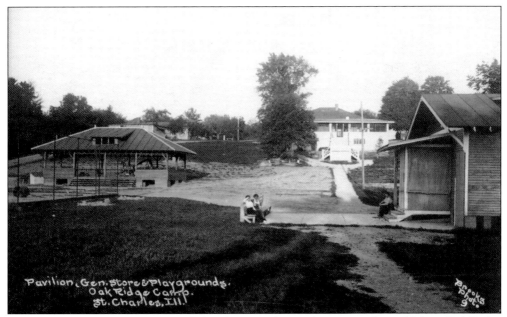

The pavilion, the general store, and the playground were the center of social life at Oak Ridge Camp. In the 1920s, the large pavilion and its dance floor gave St. Charles a reputation as one of the outstanding summer recreation spots in the Chicago area. Clyde McCoy, Isham Jones, and other big bands performed as young people from throughout the area jammed the camp on summer nights.

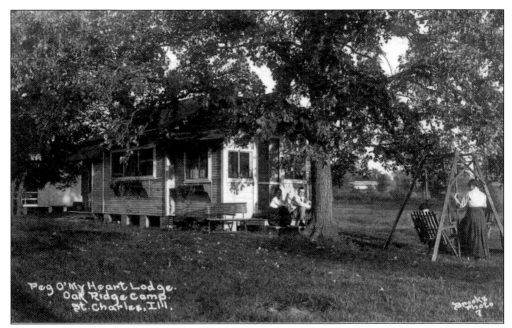

Harriet Wing joined forces with Anna Hamner in 1911 and began operating Pinelands. Then, in 1918, they bought ten acres to the south, creating Oak Ridge Camp. Harriet was the daughter of Clinton D. Wing, who was elected mayor in 1877. She had an extensive business background in marketing and advertising from her experience working for large companies in Chicago.

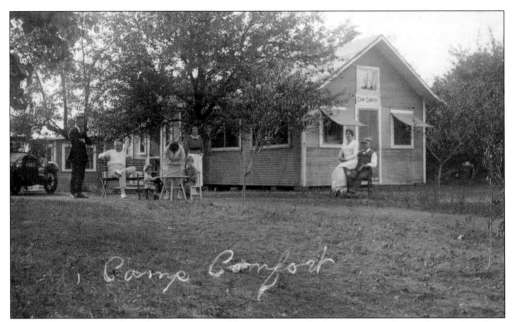

Oak Ridge Camp included many cottages like this one, which was referred to as Camp Comfort. Wing and Hamner worked hard to promote the facilities. They utilized the local media to promote the various bands, and their business letterhead read: "Completely Furnished Cottages and Bungalows of all Sizes."

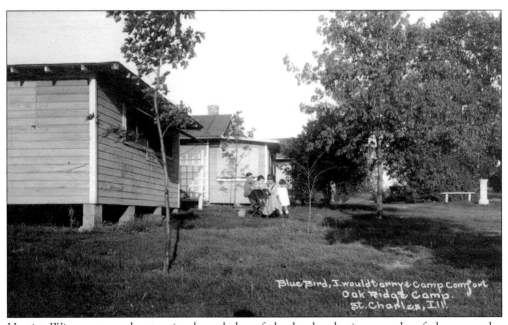

Harriet Wing possessed extensive knowledge of the lumber business, as her father owned a lumber factory in St. Charles. Eventually, they added as many as 20 year-around cottages that were built well, but economically.

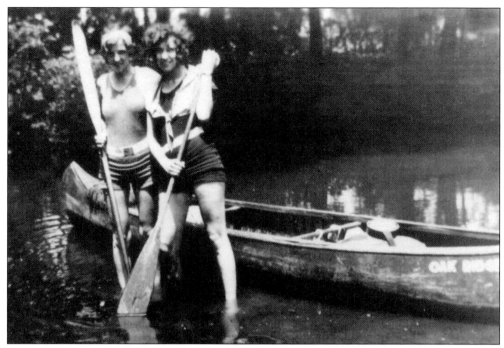

Young women "escaped" the social mores of the time as they boated along the various corners of the Fox River.

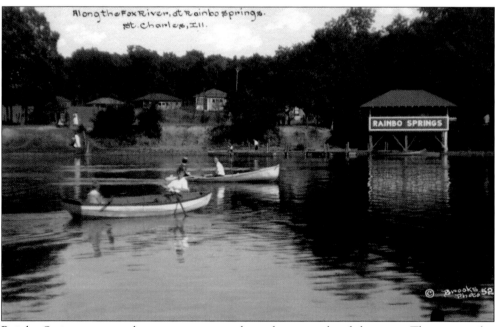

Along the Fox River, at Rainbo Springs. St. Charles, Ill.

RAINBO SPRINGS

© Brooks Photo 52

Rainbo Springs was another summer camp along the east side of the river. This resort also included a dance floor and a dining room, a popular amenity for women wanting to avoid the daily routines of cooking and meal preparation.

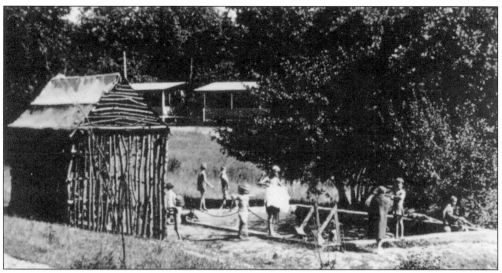

As this postcard shows, Rainbo Springs possessed a bathing pool, popular with children.

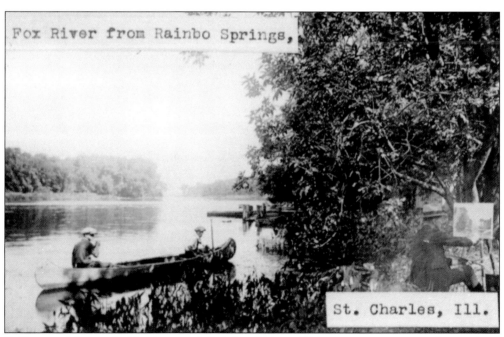

Fox River from Rainbo Springs,

St. Charles, Ill.

Dellora and Lester J. Norris owned Rainbo Springs. This summer resort to the north of Pottawatomie Park was located next to Jones' Woods, comprised of 80 acres of woods and timbers. This was a sterling addition to the nearby resort as the combination provided excellent leisure opportunities.

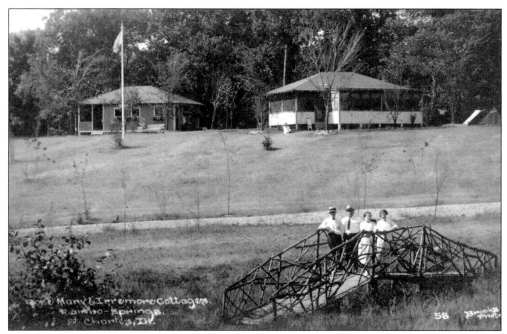

The Rainbo Springs cottages possessed good-sized screened porches, which allowed for air to circulate during the hot and humid summer nights. In addition, the development was located close to downtown, which provided easy access to nightlife. With only ten cabins in the development, the camp attracted a crowd that could afford these increased amenities.

In 1923, Sokol Chicago purchased a summer camp in St. Charles for $21,000. The organization provided physical fitness through gymnastics and had emerged as a cultural and social center for Czechs in Chicago. The camp became a gathering place for gymnastic courses and many Sokol units.

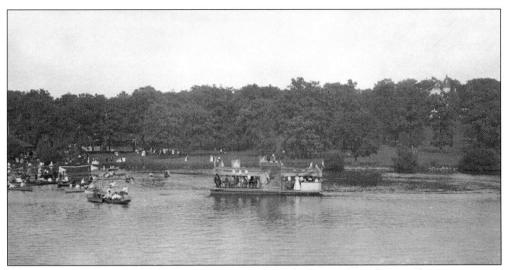

South of Rainbo Spring stood Pottawatomie Park, with the pavilion that was known to many in Chicago. The numerous improvements by the park district made it one of the most attractive spaces for vacationing.

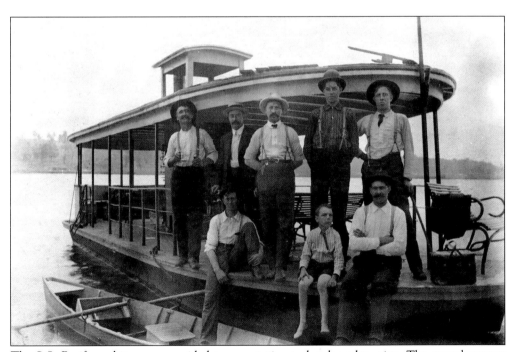

The S.S. *Pacific* and its crew provided transportation to locals and tourists. The steamboat was prominently visible on the Fox, especially near Pottawatomie Park.

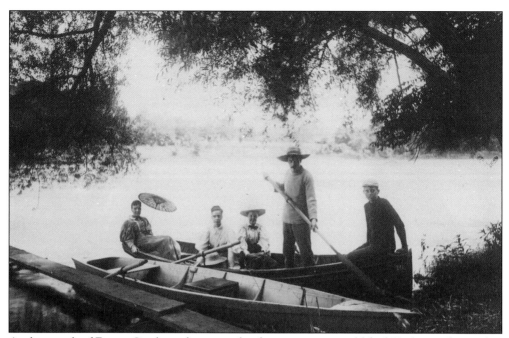

At the mouth of Ferson Creek on the west side of town, visitors could find Underwoods, another popular vacation settlement. Underwoods included rustic cottages. Many Chicago artists chose the location as a site for painting outdoor scenes. The Wild Rose Inn was located nearby.

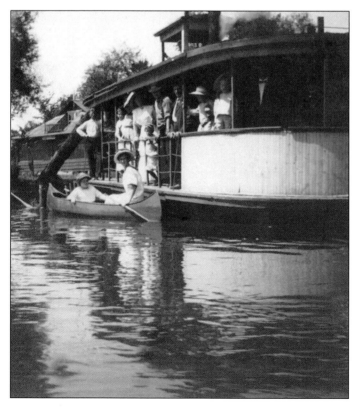

At River Grove, another popular destination north of Orchard Hill on the east side of the river, visitors could find more than 50 homes and summer cottages. Most of those belonged to Chicagoans vacationing in St. Charles.

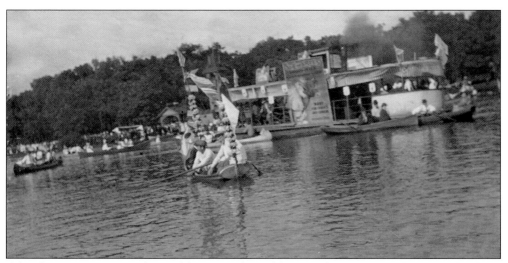

A local newspaper account boasted that an analysis of the water by Dr. R. J. Lambert of Orchard Hill showed the bacterial count there was lower than the average at the Chicago bathing beaches.

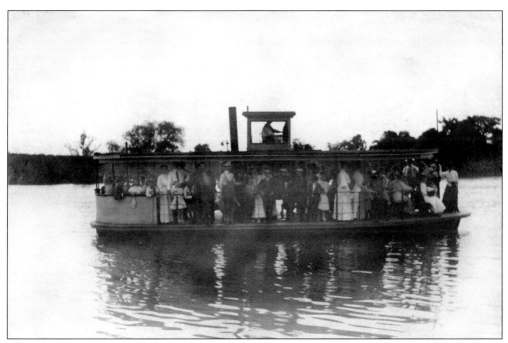

This photograph of the S.S. *Pacific* shows that boating was very popular, and leisure travel on the river was a big business. Taken in the early part of the century, this picture allows us a glimpse into the formal dress code of the period. Sunday river rides were especially sought after during that time.

Taken on the bank of the Fox, this photograph shows the crew of the *S.S. Pacific* taking a break for lunch.

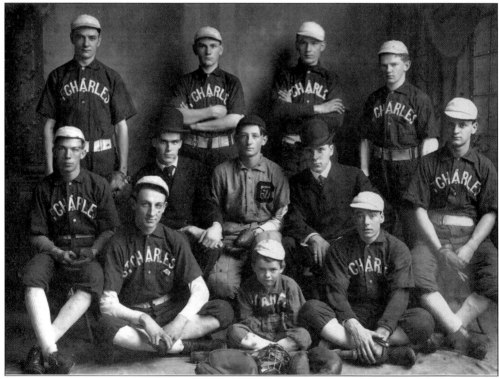

As in many other communities across the country, baseball was popular in St. Charles. This 1905 photograph depicts a town baseball team.

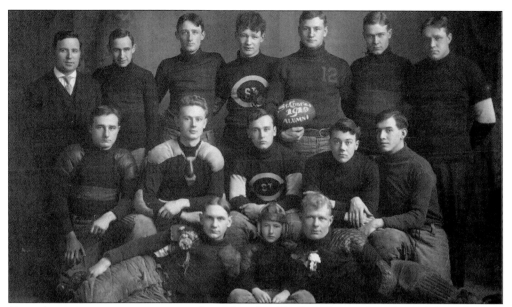

Over the years, many sports teams formed in St. Charles. These often derived from the past experiences and affiliations of the teams' founding members. This 1910 photograph shows some of the equipment used by the high school alumni football club.

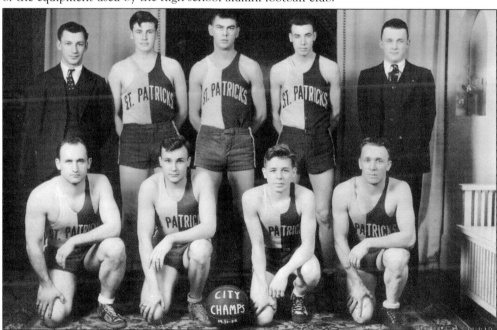

The St. Patrick's Fighting Irish were one of the most popular attractions in the early 1930s, drawing as many as 500 spectators to their games. The team was very successful in city championship games against other local semi-professional teams like McCornack Oil and the Boosters. St. Charles was well represented in district championship games against Belvidere, Woodstock, and Dundee. The team also played the Wisconsin Badgers, Chicago Bears, and even the Harlem Globetrotters, whom they defeated in 1933 by a score of 40–39 at the high school gym. A women's team in town, the St. Charles Pretzels, played against teams in Elgin and elsewhere in the Fox Valley area.

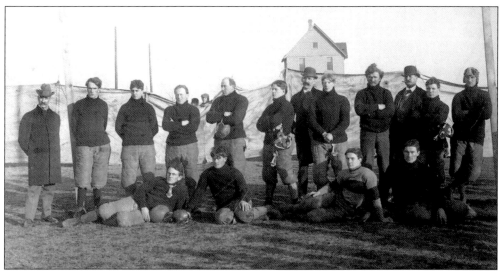

The arrival of Belgians in St. Charles with the Moline Malleable Co. also signaled increased sporting activities. Rolle Bolle was brought in during the mid-1890s, and tournaments continued in the area until recently. In addition, Belgians formed a popular football league. This photograph shows the 1899 town team preparing for a game.

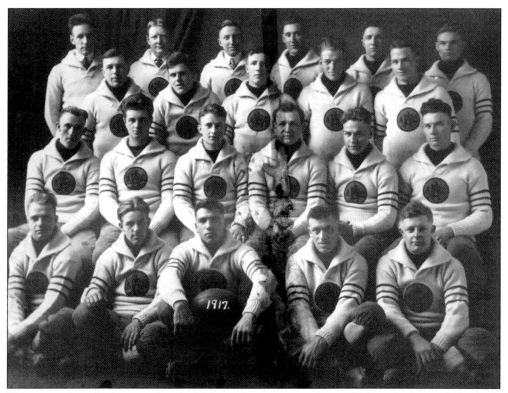

This more formal photograph of a Belgian League team from 1917 reminds us of the high interest in and importance of the sport in the community. The matching stitched sweaters reveal the extensive level of league organization that existed in St. Charles.

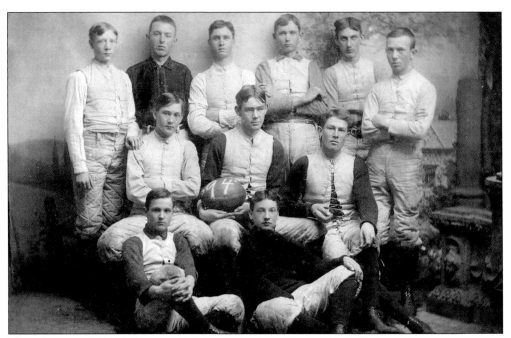

This photograph was taken in 1894, depicting a St. Charles football group.

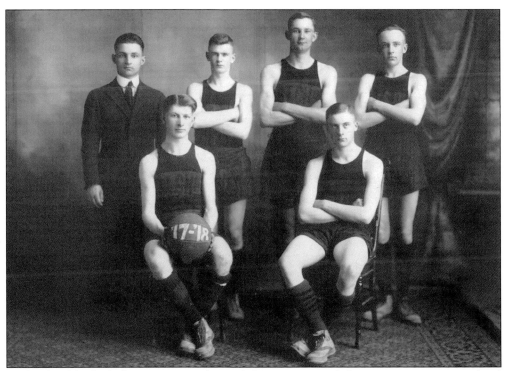

High school basketball was very popular, and the games provided great entertainment to local residents. Rivalries against Geneva and Batavia were closely followed. In the 1920s, St. Charles High School was a member of the Little Seven Conference. In addition to the aforementioned rivals, Wheaton, Naperville, Sycamore, and Dundee were also members of the conference.

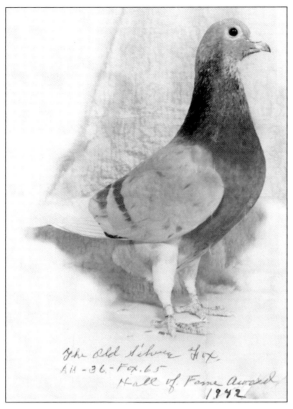

The old Silver Fox,
AH-36-Fox.65
Hall of Fame Award
1942

Pigeon racing has a long history in St. Charles. The sport came to town when the Moline Malleable Co. relocated to St. Charles in the early 1890s. It was very popular among the Belgians, who introduced the hobby to the area. Birds raced distances from 100 to 1,000 miles. Typically, they would be transported to Iowa, Nebraska, and other parts of Illinois, and then let loose to fly back to St. Charles.

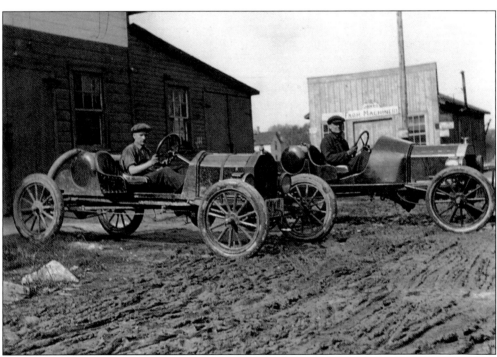

Racecar drivers pose at a farm in Wasco in the 1920s.

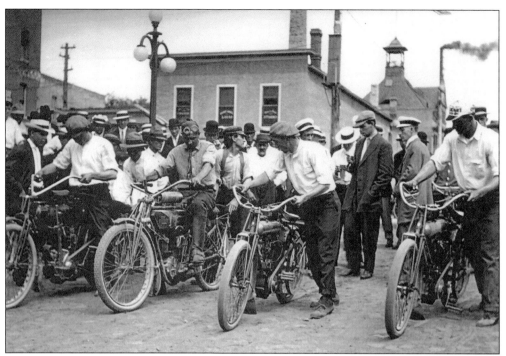

Motorcycle racing was also common in town. Here, 1920s bikers assemble along First Avenue, with the city hall in the background.

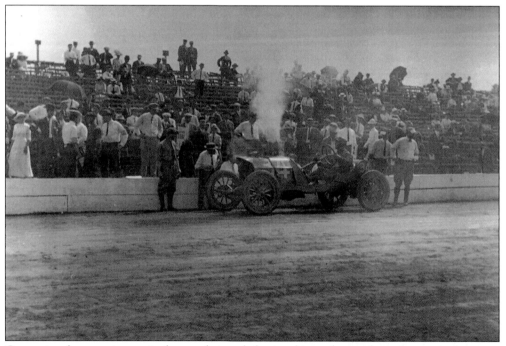

Car racing became increasingly popular, and the outskirts of town hosted organized events. A racecourse was developed in Wasco along Route 64, and as this photograph indicates, the stands held a substantial number of spectators.

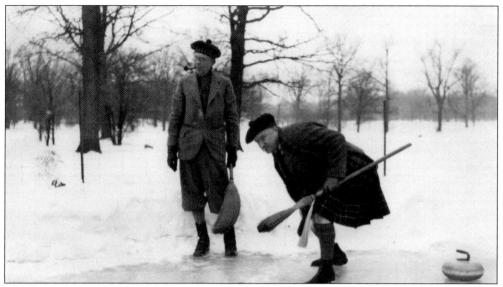

Curling was another area sport. Its origins date back in the 16th century, and the competition remains popular across Ireland, Canada, Scotland, and England, as well as in many U.S. states. Scotland is considered by many as the birthplace of the sport. Played on ice, much like a bowling alley, the object of curling is to position your team's stones closest to the center of a horizontal bulls-eye or house. These men, in the traditional Scottish attire, enjoy the game while smoking.

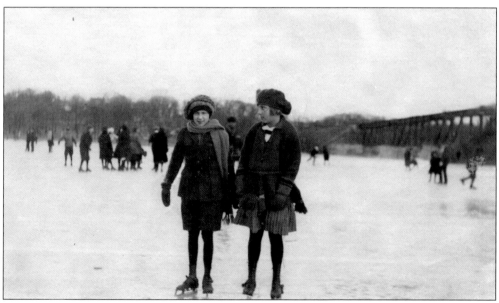

Ice skating on the river was also popular. As this photograph documents, young and old crowded the river to enjoy the fun on the ice.

Four

ARCADA THEATER AND HOTEL BAKER

The development of the Arcada Theater and Hotel Baker in St. Charles signaled the arrival of the Roaring Twenties and propelled the town into an extraordinary building boom, unprecedented for communities of this size. The population of the town was under 5,000, but the philanthropic outreach was enormous. The pioneering and entrepreneurial spirit of John Warne Gates (1855–1911), also known as "Bet-A-Million-Gates," proved to have enormous impact. A St. Charles resident, Gates had amassed extraordinary wealth in Texas by directing the production and distribution of barbed wire to cattle ranchers. He also expanded his business to oil as founder of the Texas Oil Company (later named Texaco). He and his wife Dellora Baker Gates left a substantial portion of their vast, multi-million dollar wealth to their relatives. These contributions transformed St. Charles into a Mecca of culture and leisure.

Dellora and Lester Norris built the Arcada Theater in 1926 on the eastern part of the river, and Colonel Edward J. Baker (1868–1959) built Hotel Baker in 1928 on the western edge. Both were beneficiaries of the vast Gates' fortune; they utilized their resources to create a half-a-million-dollar focal point of entertainment and a million dollar, 55-room hotel. These were just two among their many substantial material contributions.

In August 1925, the *Chicago Daily News* described St. Charles in the following manner: "A building program probably surpassing that experienced by any town of its size is underway in St. Charles, the beautiful little city perched on the wooded hills overlooking the Fox River, thirty-five miles west of Chicago. Here the heirs of the vast fortune amassed by John W. Gates are using their fortune to up build their hometown. . . . if St. Charles were only a few minutes nearer the Loop, it would be an ideal suburban town."

Closer to town, the *Elgin Courier-News* published the following commentary, reflecting on the construction activity and philanthropic commitment to the city during the 1920s: "St. Charles is a delightful city with many old-fashioned homes and estimable people. Among the latter are Ed Baker and his niece, Mrs. Lester Norris. . . . A community house, a bank building, a theater, a golf course, a new hotel—all designed and built in the most approved architectural style and without stint in the use of money, are present monuments to their generosity as well as civic pride."

Both Arcada Theater and Hotel Baker launched the town as a destination spot for tourists, weekend visitors, and conventioneers. St. Charles was not a sleepy town anymore. It now offered first-rate entertainment, high-class accommodations and related amenities, and superb natural beauty along its majestic river shores. This combination was distinct and could not be surpassed by any other area towns.

The Old Burchell Hotel was built on the current site of the Arcada Theater in 1837 and named after the man who owned and operated the facility during its early years. By 1898, the hotel was badly deteriorating, and in 1899, the building was dismantled.

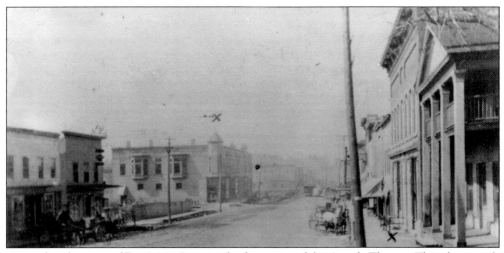

Pictured in this view of East Main Street is the future site of the Arcada Theater. This photograph was taken from the Strand Theater (building with columns on the far right) around 1905. Once the Arcada opened in 1926, the smaller theaters operating in town, such as the Strand, were unable to compete with the new technology and upscale amenities and closed their doors.

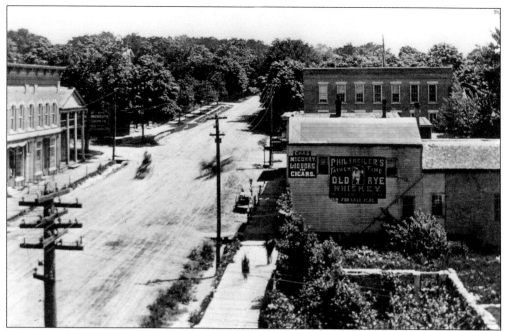

The empty lot at First Avenue and Main Street remained vacant until the start of construction on the Arcada Theater in 1925. Originally, the building was to be two stories in height. That changed in the summer of 1925 to include a much more elaborate theater design.

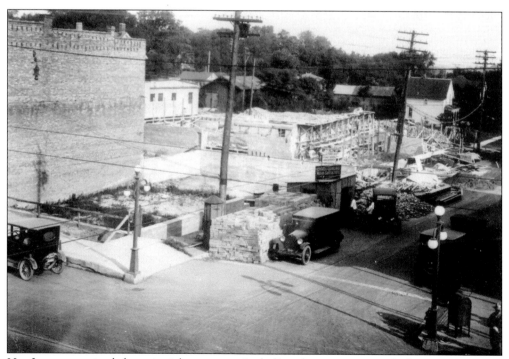

Has Jensen received the principle contract, including the carpentry work. It is interesting to note that Lester Norris moved forward with the foundation and poured the cement (visible in this photograph) in the fall of 1924, though the plans were not fully completed.

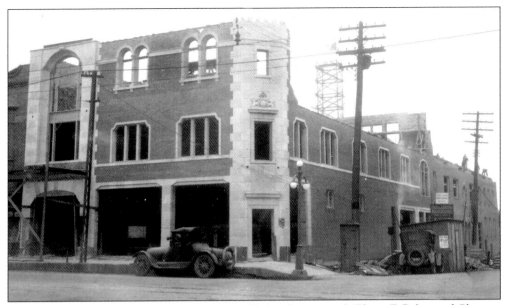

Lester J. Norris invested over $500,000 to build the theater, with Elmer F. Behrns of Chicago as the architect. Behrns also designed the Tivoli Theater and was associated with the Rapp & Rapp Co., builders of the Chicago Theater. The Arcada was designed as a Spanish Colonial Revival-style featuring brick masonry with terra cotta trim, an architectural style shared with the exterior of Hotel Baker.

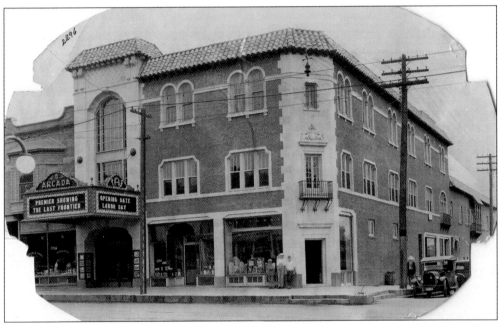

In 1926, Lester B. Colby of the Illinois Chamber of Commerce described the theater as "magnificent," "colorful," and "wonderful." He further noted: "I talked with an expert theater designer who came to St. Charles to look it over. He remarked with enthusiasm: 'Theater builders will come from all over the United States to see this theater before starting projects. It's a step ahead. It is wonderful. There is no other like it. I am charmed.'"

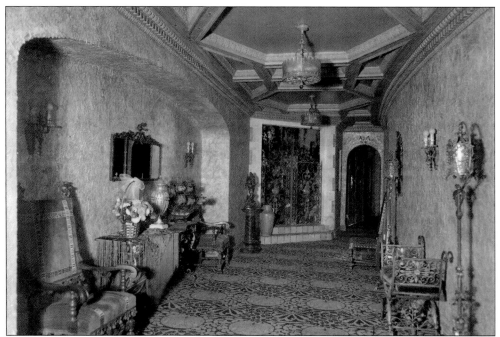

Pecky cypress was the choice wood for design of unique ceilings in 1925. Originally far less popular, it was became the desired material for the interiors of grandiose hotels and other buildings that possessed unusually decorative wood designs during the 1920s. The Arcada tearoom and the foyer which leads from the theater to the street were ceiled of this wood.

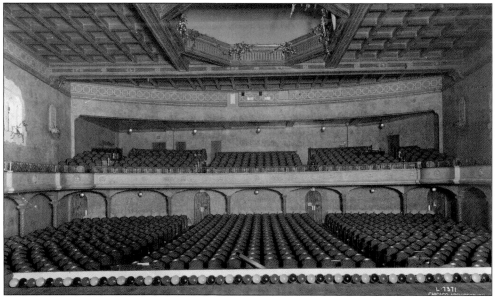

In *The Settlement and Growth of St. Charles* (1940), Alice Davis described the addition of the Arcada Theater to the community: ". . . people for miles around enjoy the music and shows in this building of unusual architecture. Quite different and how luxurious in the air conditioned auditorium with its upholstered seats and regular shows compared with the old tents of Minard's and Irwin's halls where we saw *Uncle Tom's Cabin*, or *Ten Nights in a Bar Room* once every year."

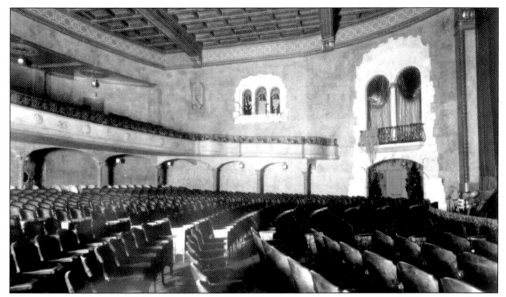

Originally, the theater had 1,000 seats and lavishly depicted numerous details of outdoor Spain. The ceiling was decorated and painted, projecting an "open air" where spectators seemed to be looking into the ether through an open roof. A rough texture was used on the walls and the ceiling was finished in light cobalt blue. A number of beams were artistically ornamented and supported by sculptured Indian heads, designed by Lester Norris. Mission bells, Andalusian jars, a lobby waterfall, and a grotto of palms in Venetian-Spanish style were some of the key exotic features incorporated into the theater's design. The ornamental hand-wrought iron gates for the front foyer and the main auditorium were made in Venice, Italy.

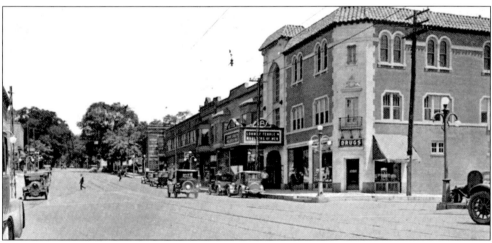

This photograph of East Main Street was taken after the opening of the Arcada on Labor Day 1926. On March 18, 1926, the *St. Charles Chronicle* claimed: "There may be larger theaters in Chicago, but for beauty of auditorium and artistic stage setting, there are none superior to the Arcada of St. Charles. It is the last word in elegance and will of itself set the country talking about St. Charles." In August 26, 1926, just days before the opening day, the paper declared: "In Chicago, and in all towns surrounding St. Charles, inquiries come in hourly about the opening of the Arcada Theater. It will be a gala day in St. Charles." A 1926 issue of *The Exhibitor's Herald* noted: "In the Arcada is to be found a grandeur seldom approached."

The Last Frontier was the theater's opening feature and *La Boheme* was scheduled in the fall of 1926. Other early performances included the *Nervous Wreck*, which was touted as a "high class" comedy. Several hundred theatrical guests arrived from Chicago for the opening. Over the years, a number of theater groups operated in St. Charles. This is the cast of the *Family Upstairs* by Little Theater taken in 1933. The group involved some local high school students.

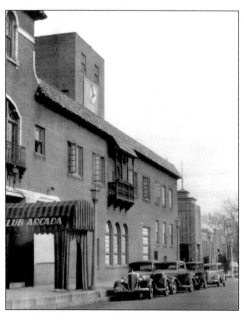

Many theaters in the 1920s combined space uses. Consistently, the building contained shops and office space. Some of the original tenants included Helmer's Drugstore, the Chas. Belyera Men's Wear Shoppe, the Red Parrot Tea Room, and the Chronicle Publishing Company. The third floor originally housed the St. Charles Masonic Lodge #48. Club Arcada next to the theater was a popular nightspot from the 1920s to the 1940s. Norris introduced what he called the "super club," influenced by design elements of the famous El Morocco in New York City. Zebra upholstery and palm trees dominated the décor.

ARCADA THEATER
Distinctly Different

Sousa AND HIS Band

Top performers at the Arcada included George Burns and Gracie Allen, Edgar Bergen and Charlie McCarthy, Olivia DeHavilland, the John Phillip Sousa Band, Cornelia Otis Skinner, Vincent Price, Lee Remick, Jeanette McDonald, Walter Slezak, and Maria Von Trapp.

The Arcada Theater featured the finest organ outside Chicago. Concerts by organist Herald Peterson were broadcast on Chicago radio stations throughout the 1930s. Before the emergence of talking films, the theater was one of the Fox Valley's leading vaudeville houses. Regarding the organ at the Arcada, the *St. Charles Chronicle* reported on December 24, 1925: "After a careful investigation an organ has been purchased for the Arcada Theater, a MARR & COLTON, made in Warsaw, N.Y. . . . the factory will make changes according to plans outlined by Lester Norris and Wm. Pracht, who are most desirous of installing the finest organ in the country. On the whole, this instrument will be an attraction for everyone who enjoys high-class music. A proficient organist will be engaged in who will bring out fully, the tones. The price of the organ is upward of $25,000."

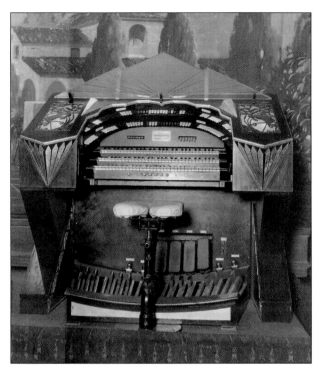

This theater production of *Bittersweet* at Arcada in the early 1950s starred Jeanette MacDonald.

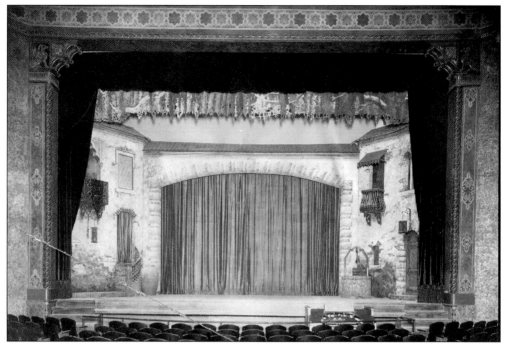

The stage was the largest in the valley, measuring 27 feet by 75 feet, and its background was set in old Madrid. The *St. Charles Chronicle* described the stage on September 2, 1926, a few days before the opening: "And the stage! The ancient street homes where Columbus, with his followers, may have passed on the way to boarding the Santa Maria when setting sail to an unknown east in 1492, are depicted."

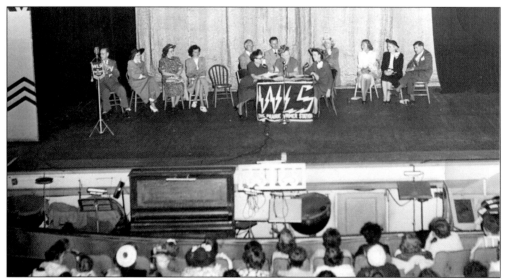

Lester Norris wanted the design of the Arcada Theater to be up to par and to compete effectively in comparison to other structures. For example, the organ was similar to the instrument purchased by the million-dollar Egyptian Theater scheduled to open at that time in Milwaukee, and all booth equipment was similar to equipment found at that time in the Chicago Theater. Radio stations like WLS broadcast from the Arcada.

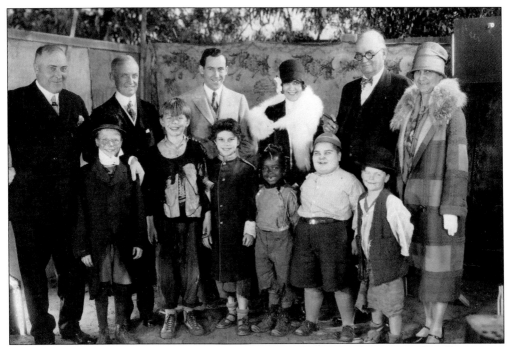

The original cast members of the "Our Gang" vaudeville pose with Lester and Dellora Norris (center). The California group was popular in the late 1920s.

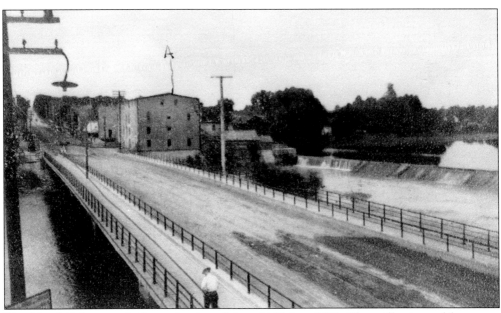

The Hotel Baker was built at the site of the old Haines Mill. The mill, pictured here, was constructed in 1837 and destroyed by fire in 1919. In the 1920s, the site was increasingly used as a dumping ground for garbage. Edward J. Baker, brother of Mrs. John Gates and one of the heirs to the Gates fortune, decided a dump should not be the focal point of his home town. While numerous hotels existed in St. Charles dating back in the 1850s, Edward Baker would build at this site a facility that would become "the finest small hotel in the United States."

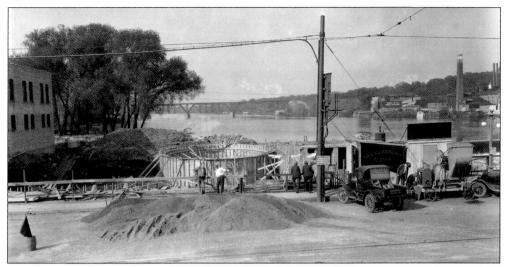

This photograph was taken in 1927 during the early stages of construction on the Rainbow Room. Workers broke ground in September of 1926 and initially expected to complete the project by the summer of 1927 at a cost of $600,000. The hotel finally opened on June 2, 1928, at a cost of $1,000,000. The reason for the delay and the increased price tag was to make certain every detail received the attention needed to ensure the beauty of the final product. Built on the Chicago-Iowa trail (Route 64) and Route 22 (Route 31), and situated one-half mile from the Lincoln Highway (Route 38), the hotel was to be named Hotel St. Charles. When it opened as Hotel Baker the building was called the "Gem of the Valley," adding to the ascending reputation of St. Charles as the "Beauty Spot of the Fox River Valley."

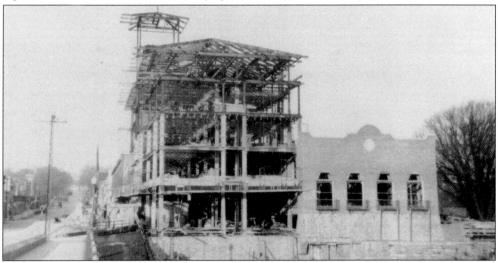

On June 2, 1928, the *St. Charles Chronicle* published a supplement entitled "Hotel Baker." The document provided many details about the construction of the hotel and its unique features, including its organization to ensure superior service to guests. Edward Baker was asked to comment. He noted: ". . . in this my third effort, to build beauty and utility in your town and mine, it will bring to you and your children happier moments and make you and them a little more pride in the dear old St. Charles, then I have brought nearer my realization of an ideal which I have held in my heart ever since it was made possible to share with all St. Charles, the beauty and utility which together make for advancement."

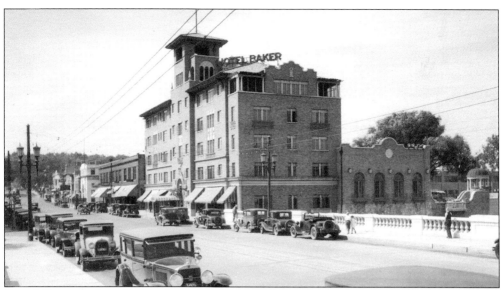

Over 300 people from St. Charles and the surrounding cities attended the opening dinner of the Hotel Baker. Ellen Johnson, a St. Charles resident, remembers the grand affair: "The hotel was the colonel's toy, best of everything from the radio studio on the top floor to the automatic toasters that guarantee the golden brown hue of golden toast. The opening night was the talk of the town, everybody was swimming with joy. And with the lights hooked up to the player organ, and the lights flashing out on the dam and the designs changing under the floor, well it just went hog wild. The people were in an uproar. They'd never seen anything like it."

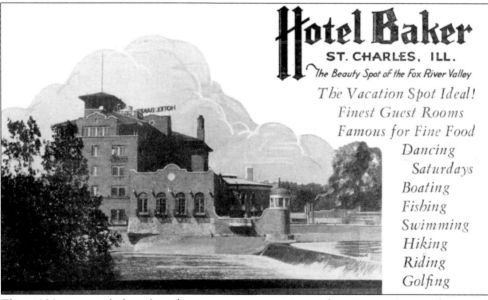

Hotel Baker
ST. CHARLES, ILL.
The Beauty Spot of the Fox River Valley

The Vacation Spot Ideal!
Finest Guest Rooms
Famous for Fine Food
Dancing
Saturdays
Boating
Fishing
Swimming
Hiking
Riding
Golfing

This 1930s postcard describes the numerous amenities and activities. It was during that period the resort hotel developed a national reputation as the "Honeymoon Hotel." Fifty-five elegant, upscale, appointed and distinct suites, its numerous recreational opportunities, the nearby Pottawatomie Park, and the live entertainment at Arcada Theater made it a vacation destination spot. In the late 1920s, accommodations started at $2.50 per night. By the mid-1940s the cost was $6 per night.

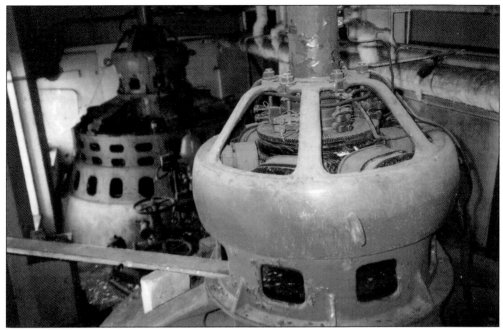

The hotel generated its own electricity, powered by water from the Fox River. A raceway built under the hotel channeled water through two 50-kilowatt generators, a feature that helped the hotel avoid power outages during storms. The two generators also supplied electricity to the nearby Arcada Theater.

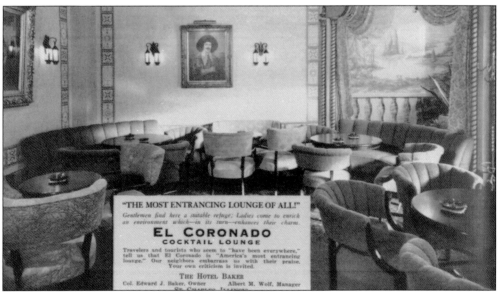

"THE MOST ENTRANCING LOUNGE OF ALL!"

Gentlemen find here a suitable refuge; Ladies come to enrich an environment which—in its turn—enhances their charm.

EL CORONADO
COCKTAIL LOUNGE

Travelers and tourists who seem to "have been everywhere," tell us that El Coronado is "America's most entrancing lounge." Our neighbors embarrass us with their praise. Your own criticism is invited.

THE HOTEL BAKER
Col. Edward J. Baker, Owner Albert M. Wolf, Manager
St. Charles, Illinois

The lounge of Hotel Baker was also referred to as the Trophy Room. It was there Edward Baker kept his horse racing trophies and valuable portraits of his famous "Greyhound." The room was decorated to portray the courtyard of a Spanish mansion with Moorish influence. The walls replicated the exterior of buildings surrounded by eaves, balconies, and canopies. The ceiling was painted and lit to replicate moving clouds in the open sky, and a canopy dominated the center of the space.

80

This large, Spanish Renaissance-style pipe organ was positioned between the Trophy Room and the Rainbow Room. It was unique because it could play rolls for both the organ and the piano, and the stops could be adjusted to create a jazz effect.

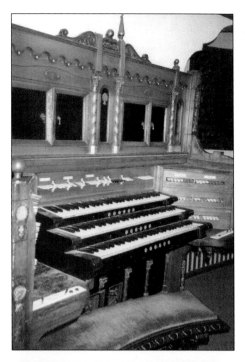

This postcard depicts the impressive formal rose gardens. Guests strolled its well-groomed paths and drank and dined under the umbrellas (visible in middle of photograph) on the hotel terrace. This was a glamorous and fashionable setting for high society. In this 1929 postcard, the writer described her impressions: "We had dinner at this new hotel—the Sunday before the last operation—and I bought these cards to send to you—thought you might enjoy seeing what John Gates' money is doing for St. Charles—I can only say I think it would be more practical if there were some rooms furnished more for people of ordinary status."

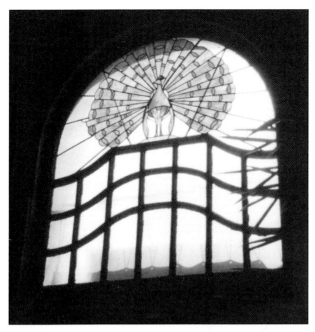

The firm of Wolf, Sexton, and Trueax of St. Charles designed the hotel featuring a combination of Spanish and Moroccan styles. The building included numerous details in Baroque décor. A key feature visible to all entering the hotel was this stained glass peacock window positioned above the entrance. It was one of the initial impressions of every guest.

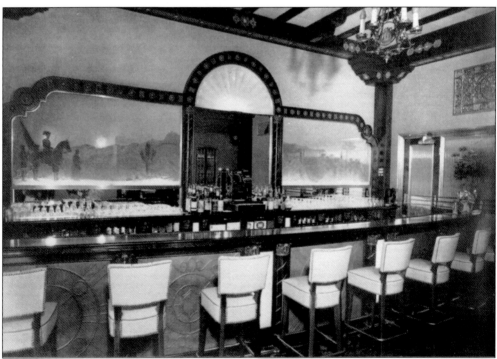

Key architectural features included the fine, hand-painted walnut beams, imported marble floors, a fountain made from granite, and an impressive grandfather clock imported from Germany. Bert Norris, a local furniture dealer, provided furnishings for the hotel reportedly valued at more than $100,000. Imported floors and rugs from the Middle East and China and distinctive works of art dominated the lobby and the hallways. One of the art pieces, *The Wedding*, by Pietro Gabrini, was valued at $6,000 in the 1920s.

Many famous people stayed at the Hotel Baker over the years. Amos Stagg, Baker's friend, was the first guest. Others included John F. Kennedy, Gerald Ford, Jim Thompson, Everett Dirksen, Adlai Stevenson, Edmund Muskie, Charles Percy, Richard J. Daley, Billy Graham, Len O'Conner, Jeanette MacDonald, Mary Arnold, Edgar Bergen, Tommy Dorsey,

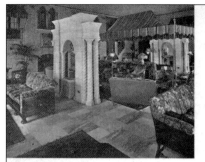

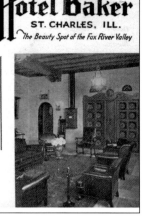

Hotel Baker
ST. CHARLES, ILL.
The Beauty Spot of the Fox River Valley

THE LOUNGE is built over the dreamy waters of the Fox River and opens out upon terraces overlooking the formal gardens and park. Throughout the Lobby and Lounge and in the Waiting Room are hung acknowledged masterpieces of modern and 19th Century painting. A beautiful Spanish organ console dominates one end of the patio and luxurious chairs and davenports bid you rest and enjoy its music.

and Lawrence Welk. Many of these entertainers performed at the Rainbow Room or the nearby Arcada. Edward Baker was a staunch Republican, and at times, the hotel served as the local headquarters for the Republican Party, hosting many political events and Illinois governors.

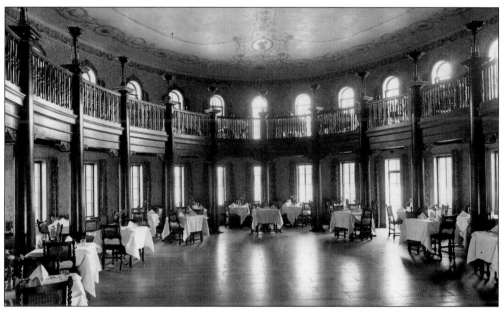

This two-story, oval ballroom and dining room was surrounded with a balcony that originally used brass torches to provide light. It was called the Rainbow Room for the dance floor, which had 2,620 yellow, red, green, and blue lights under 300 glass blocks. The lights were set in units of four, with each lamp in the unit of a different color. A total of 554 units illuminated in rows or quadrants. The board that controlled the lights cost $6,000. At the time, this was only one of three such lighted floors in the world. Music and lights were synchronized, offering some of the best entertainment experiences. The show included lit patterns forming stars, a Christmas tree, a Valentine heart, the American flag and many other figures. Famous entertainers at the Rainbow Room included Louis Armstrong, Guy Lombardo, and Lawrence Welk. In the 1930s and 1940s, Chicago residents flocked to the Fox River Valley, and for $1.50 per person, they danced the night away to Tommy Dorsey and Eddie Duchin.

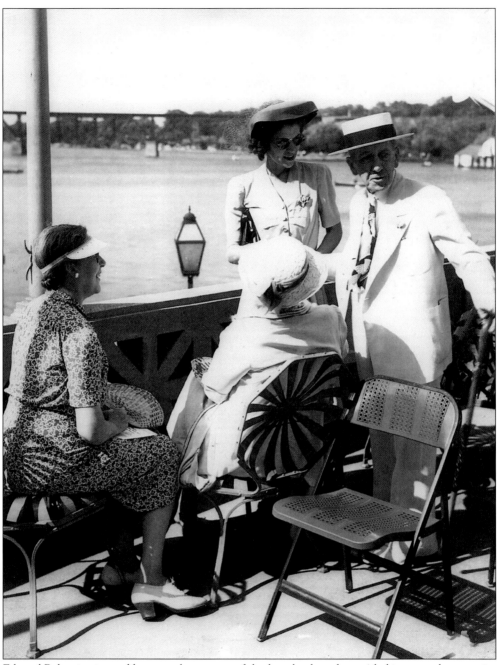

Edward Baker is pictured here on the terrace of the hotel, where he resided in a penthouse suite on the fifth floor until his death in 1959 as age 90. Baker's wife Harriet died in 1940. His niece, Dellora Norris, stands beside him.

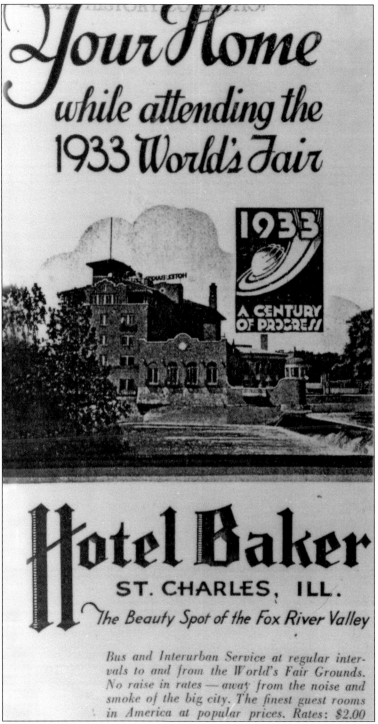

Your Home while attending the 1933 World's Fair

1933 A CENTURY OF PROGRESS

𝕳𝖔𝖙𝖊𝖑 𝕭𝖆𝖐𝖊𝖗

ST. CHARLES, ILL.

The Beauty Spot of the Fox River Valley

Bus and Interurban Service at regular intervals to and from the World's Fair Grounds. No raise in rates — away from the noise and smoke of the big city. The finest guest rooms in America at popular prices. Rates: $2.00

In 1933, during the World's Fair in Chicago, Hotel Baker was advertised as one of the best locations in the metropolitan area.

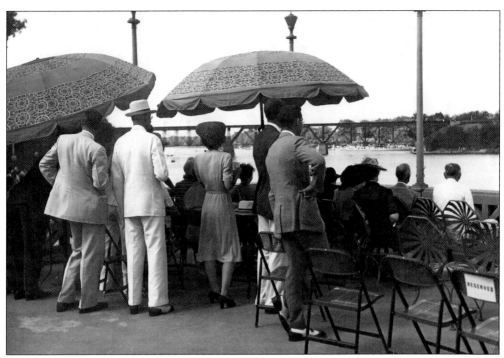

This 1934 photograph shows Edward Baker's invited guest party enjoying the dedication ceremony of the World's Fair gondolas in St. Charles. After the Chicago World's Fair in 1934, the fair's board of directors gave Baker three Venetian gondolas. The boats were stored in the boathouse, and hotel guests could rent them, along with a singing gondolier, between eight o'clock and midnight during the summer time, to enjoy a ride on the river.

Each room was unique, but they all possessed the latest amenities. R.L. Wagner Co., a local plumbing provider, equipped the building with the best features of the time. "Invisabowl" lavatories, for example, folded behind French doors in each room. The tubs afforded footbaths, since they were 12–15 inches deeper at the drain. To conserve energy, their lower part could be filled up, while the rest of the tub stayed dry.

Five

POTTAWATOMIE PARK, MUNICIPAL BUILDING, AND COUNTRY CLUB

All three of these major developments occurred in the northeast quadrangle of St. Charles, along the Fox River, during the 1920s and 1930s. While the history of Pottawatomie Park dates back to the 1800s, it formally became a park in 1911, and many of its major amenities (swimming pool, golf course, etc.) were not developed until the 1930s. The St. Charles Country Club was established in 1924. The architecturally distinct Municipal Building was constructed in the late 1930s and dedicated in 1940.

Their collective outcome signified the town was moving forward by formalizing and institutionalizing its natural attractions and civic capacity, offering them to residents and visitors alike. Pleasure seekers poured into the area on summer weekends to enjoy picnics, canoe up and down the river, and cruise on the picturesque paddlewheel boats. The development of the St. Charles Country Club attracted and maintained a business and cultural elite, projecting a community uniquely different from nearby towns and other Chicago suburbs. Finally, the construction of the Municipal Building not only provided much-needed space for government functions; it also built upon the civic and cultural advancements of St. Charles during the previous two decades. It amply signified the culmination of a golden era, thrusting the community forward. It is important to note here that all of these projects would not have been possible without the contributions and philanthropic outreach of the Baker and Norris families who almost single-handedly transformed this small town.

Pottawatomie Park in the late 1800s was the perfect resort. According to a 1900 newspaper account: "The families come out from the smoky, grimy city to spend the day and they go back perfectly satisfied that they are as tired and happy as they well could be. No better resort could be found." Similarly, a St. Charles Chamber of Commerce publication in 1926 described Pottawatomie Park in this regard: "Here are 20 acres of natural wood-land sloping down to a clean cut river-bank. Added improvements are in keeping with this rustic setting, and consist of walks, terraces, fountains, buildings and play ground equipment. Bathing and boating are good here."

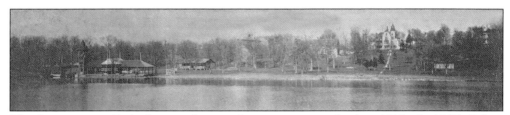

This Pottawatomie Park photograph was taken sometime in the late 1890s. In 1835, Calvin Ward purchased the land (north of East Main Street and west of Fourth Avenue along the river) for $75 from Evan Shelby. He traveled west and left the property to his son Lorenzo Ward, a farming and dairy businessman, who built the large mansion overlooking the Fox River. The house was a showplace, set in a well-developed wooded grove with terraces and stone steps leading down toward the shores. It burned down in the early 1900s.

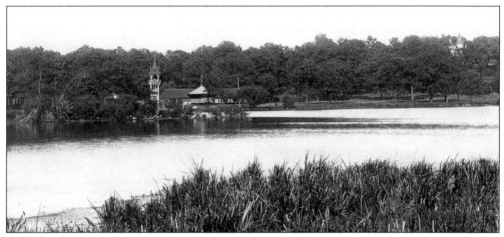

This popular postcard of the park was taken sometime after 1892. In the summer of 1885, Lorenzo Ward lost a parcel of the land south of the mansion to construction by the Chicago Great Western Railway Company. Following a long and expensive legal battle and disappointed by the turn of events, Ward sold the remaining land to developers A.B. Stickney of St. Paul, Minnesota, Clinton D. Wing, and Charles H. Haines of St. Charles. Their plan was to develop the property as a resort with a park and a hotel for railroad travelers.

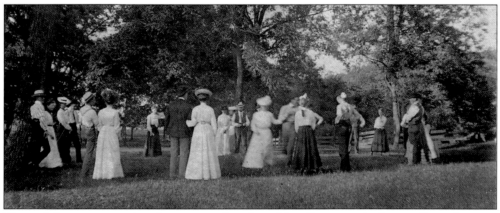

The park became a popular place as crowds gathered for afternoon picnics, strolls, and games. As this late 1800s photograph illustrates, couples would gather to meet, socialize, and dance.

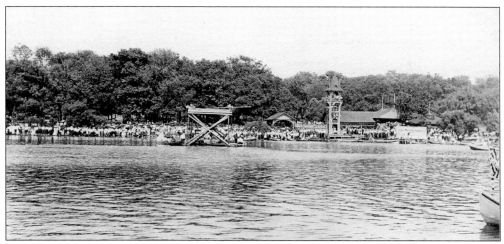

This photograph was taken in 1911, an important year in the history of park. On July 1, 1911, an act of the general assembly of the State of Illinois calling to "establish and maintain parks and parkways in the towns and townships," became a law. That day, Bert C. Norris, a local funeral home businessman, started a petition to the circuit judge of Kane County, asking the appointment of a park commission for St. Charles Township. The petition was quickly filed and the appointment was made on July 5, 1911. An election was held on November 18, 1911 regarding the issue of $23,000 in bonds; 584 voted in favor to 207 against. On May 20, 1912, Pottawatomie Park became the property of the people of St. Charles and the first public park in the State of Illinois. Following a number of improvements, it has become a destination spot in northern Illinois.

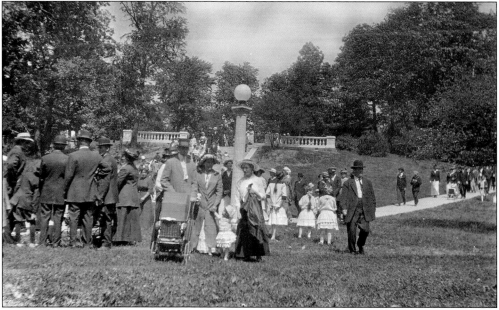

Sunday visits to the park after church were also very popular. This photograph was taken sometime in the summer of 1915 and shows people arriving for afternoon gatherings and strolls along the river. Located on the east side, the steps and courtyard shown at center served as the formal entrance to the park. The "proper" attire of the families signifies the park also served for formal social interactions.

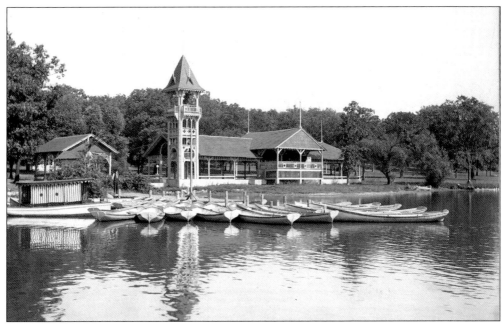

The pavilion served as a focal point of the park. It was constructed in 1892, and in the early 1910s, a 20' x 29' cement floor was added for dancing. The tower shown here was removed in the late 1950s, and in 1988, a gazebo replication of the tower was constructed in Lincoln Park on the west side of St. Charles. Renting a boat was a popular activity that allowed visitors to enjoy the beauty of the river and its shores. While the building stood for many decades, an effort to recreate the architectural details of the structure, including the tower, is currently underway.

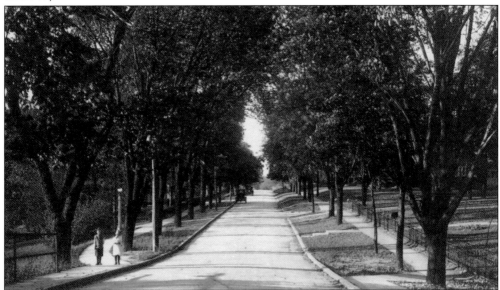

This tree-lined street provided a pleasing entrance to Pottawatomie Park. A formally landscaped view denotes the importance of the setting adjacent to upscale residences. Taken around 1900, the photograph captures two children, perhaps on their way to enjoy a pleasurable day at the park.

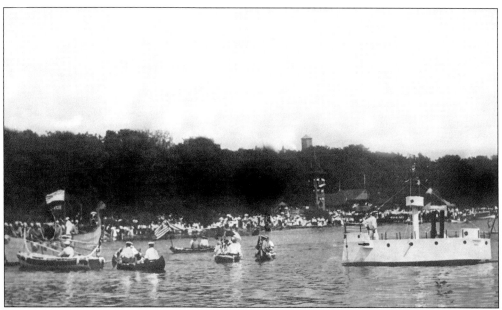

This view of the pavilion from across the river shows the popularity of the park as big crowds gather to celebrate. Events like the river festival, still happening today, attracted not only St. Charles residents, but also visitors from the Fox River Valley and beyond.

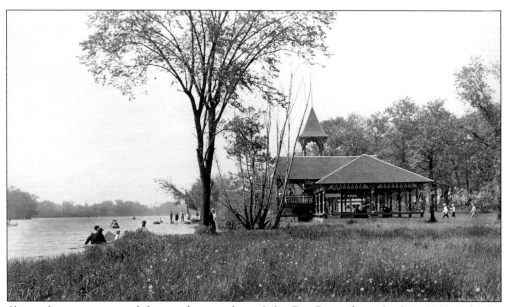

Shown here is a view of the pavilion, park, and the Fox River from the late 1920s. The *St. Charles Chronicle* described Pottawatomie in a 1900 issue: "But just at this spot above the dam it broadens out to a large expanse of a quite limpid nature, over which a majestic little stream launch and scores of row boats find their way. Picnics are of daily occurrence . . . tables and benches are scattered here and there among the trees, boats are innumerable, the stands do a rushing business in ice cream soda, pop, etc. . . ."

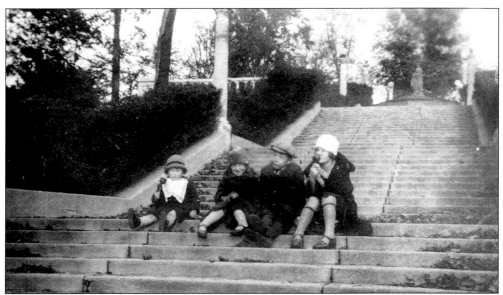

Kids sit at the park entrance steps in 1926. The staircase entrance to the park was added in 1915 and included a bronzed statue of a Pottawatomie Indian. Wilfred M. Doherty in his August 19, 1915 dedication ceremony speech concluded: "As we dedicate this statue, this tribute to the nobleman, the Indians who loved this spot and this nature so well, let us here in the beauty spot of Northern Illinois, on the banks of the most beautiful river in the middle west, dedicate ourselves to the ideal which this day exemplifies, a united and loyal people and a more beautiful and more prosperous St. Charles." The statue, an object of much vandalism, was removed in the 1960s. In the late 1970s, park officials wanted to remove the staircase that had fallen into disrepair. Public outcry led to the refurbishment and preservation of the staircase.

Over the years, various views of the park were captured in popular postcards. In one of these cards, postmarked April 24, 1909, the writer reflected on her experiences at the park: "Hello Emma: Didn't see you last night at the dance. How was it? We had a very nice time at the Pavilion. Great time! Sure I was in St. Charles last night." Bridges and sidewalks were added throughout the park in the early 1910s.

In the 1930s, when the area was affected by the national economic depression, the park board, with the support of the citizens, decided to apply for Works Progress Administration (WPA) government funds. The program was founded by President Roosevelt as part of the New Deal. The St. Charles application was approved, and one of the largest federal grants was awarded to the city for park improvements. Over 400 locals were employed by the administration for the Pottawatomie Park development. Coupled with the generous financial support of the Lester J. Norris family, a number of park projects were completed by 1939, including a swimming pool complex and building, a nine-hole golf course, a band shell, an amphitheatre, and a baseball field complete with bleachers and lighting.

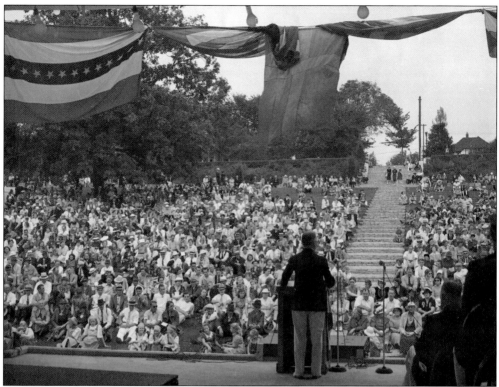

Part of the park improvements included the amphitheatre, which was constructed by terracing the hillside on the east edge of the park. The terracing was designed to be of grass with stone steps leading down the center and along each side. The facility was dedicated on Memorial Day 1938 to "All War Veterans" (photograph above). It was primarily used for concerts, addresses by notable public figures, and other community events.

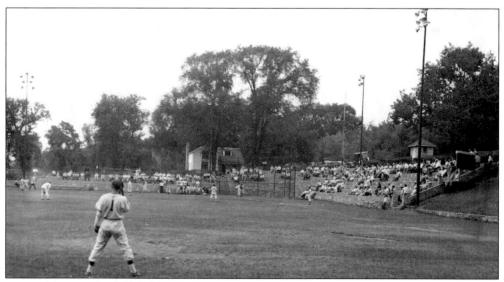

Pictured here is the ball field at Pottawatomie Park during a game from the late 1940s. The facility is still in use by the park district.

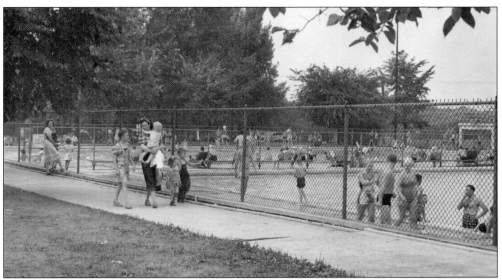

The swimming pool at the park opened on August 6, 1938, and quickly became a popular family destination spot as evidenced by this picture from 1946. Funds were donated by the Lester J. Norris family to obtain the needed land for the project. In addition, a $34,000 bond was approved and issued to purchase lots and some nearby summer cottages. During the first week of August 1938, 500 citizens enjoyed the pool on Monday and 900 on Wednesday. Fees on opening day were: children 10–18 years—10 cents; 18 years and over—25 cents; under 10 years—free.

Women golf at the park sometime between 1946 and 1948. Located in the northern portion of Pottawatomie, this nine-hole golf course occupied 42 acres of land. During that time, the land was valued at $50,000 and was given by the Lester J. Norris family. Robert Trent Jones, one of the premier golf course architects at the time, designed the course, which was completed on July 1, 1939. The total cost of the pool and golf complex was $445,000.

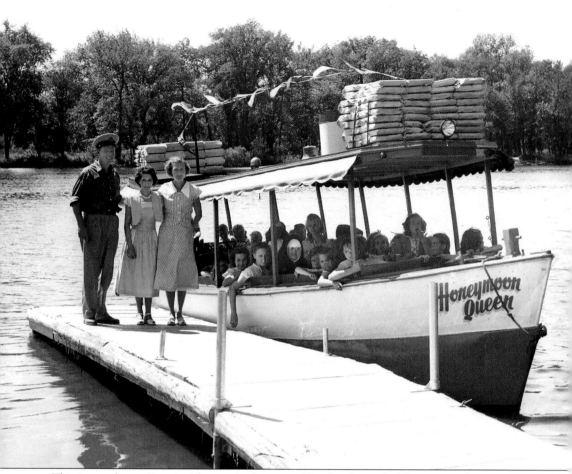

This image shows Captain Chester Anderson and his first boat, the *Honeymoon Queen*, in 1940. Ferry rides up and down the shores of the Fox River were a popular attraction for many decades. This photograph of an elementary school outing depicts a group of anxious children ready for an enjoyable ride.

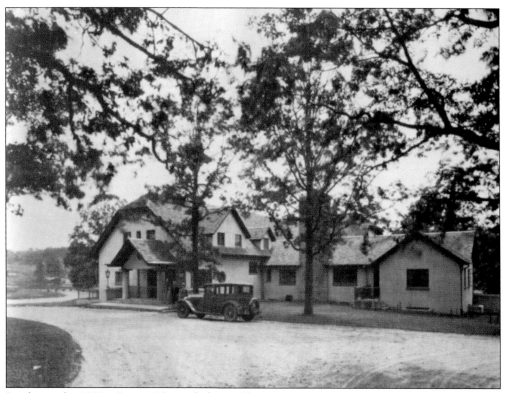

In the early 1920s, Lester Norris led an effort to create a country club. The St. Charles Commercial Club was looking for ways to create a first-class golfing environment for men. The Norris's agreed to provide needed financial support, and the S.H. Lee property, high on the north and east side of the river, was purchased. The St. Charles Country Club was established in 1924, and an eighteen-hole golf course and a clubhouse were completed in 1926.

Many social activities highlighted the early years of the St. Charles Country Club. Formal dances, bridge parties, informal gatherings, ladies' games on Tuesday afternoon, children's Christmas parties, costume parties, and well-organized and attended New Year parties were a mainstay. The annual Fox Chase party was very popular in the late 1920s, attracting more than 100 guests.

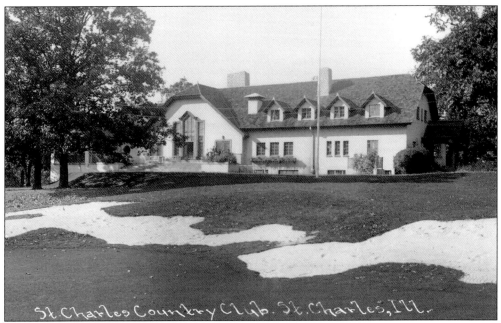

St. Charles Country Club. St. Charles, Ill.

The original clubhouse burned down in 1943, and a larger one was built shortly thereafter. The Great Depression had a direct impact on the country club. Memberships declined even though the club reduced fees and Norris helped subsidize operations by a gift of land along the ninth fairway. In July 1932, the board, under the leadership of President Norris, decided to expand by opening the club to families. As a result, they introduced a swimming pool, tennis courts, bowling on the green, shuffleboard, and a skeet-shooting range, ensuring the club's survival and future viability.

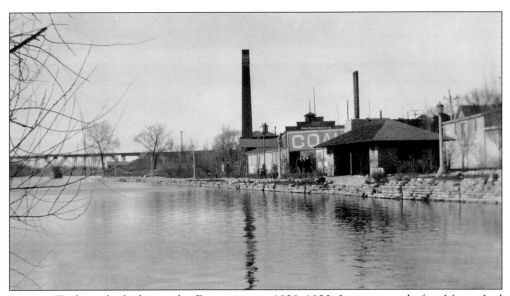

Langum Trail was built during the Depression in 1929–1930. It was named after Mayor Ival Langum who served seven consecutive terms as the 13th mayor of St. Charles from 1929–1957. Note the milk and sugar factory and the condensing milk factory in background on the east side of the riverbank. Pottawatomie Park is located around the corner, north of the railroad bridge.

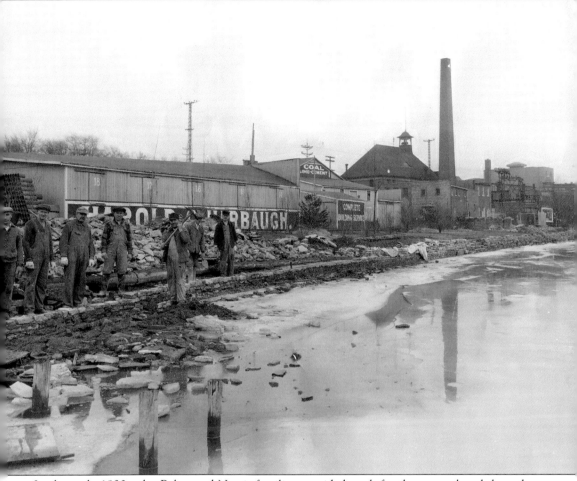

In the early 1930s, the Baker and Norris families provided work for the unemployed through a beautification and recreation project on the east side of the river (funds also came from the Works Progress Administration). The men in this 1929 photograph work to construct the Langum Trail. North Avenue and the current Municipal Building would be located to the far right of the image.

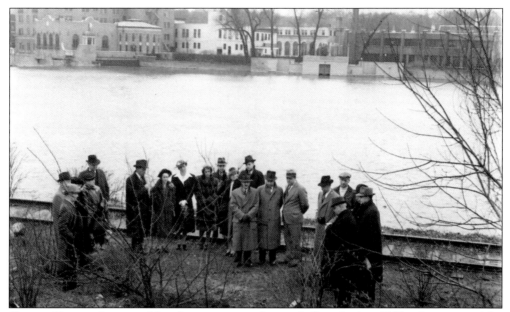

Captured here is the ground-breaking ceremony for city hall in the late 1930s. A portion of the Great Western Railroad, which ran along the river from the Great Western tracks to North Main Street, is clearly visible in the background. To the east, right on the river, there was a lumber yard (First Avenue and Cedar Street), just north of the city building. This spur brought lumber there. Hotel Baker is clearly visible on the west side of the river.

In March of 1928, the St. Charles Fixture Company burned. The site remained empty until it became home to the St. Charles Municipal Building. The facility was donated to the city by the Baker and Norris families through St. Charles Charities, a local granting organization started in 1924 by the two philanthropists.

The Art Moderne structure was designed by architect Harold Zook in association D. Coder Taylor and completed in 1940. Zook planned the building to complement the Hotel Baker and the Main Street Bridge (designed by Lester Norris and completed and expanded in 1927) that featured elegant concrete and marble-chip balustrades topped by four bronze foxes, donated by Herbert P. Crane and imported from France. The building was entered in the National Register of Historic Places in 1991.

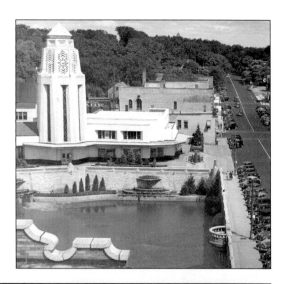

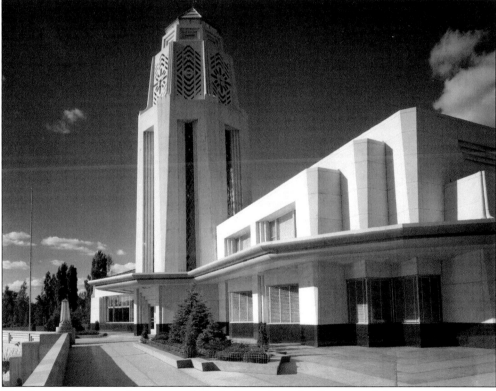

The floor plan follows the river, and Zook chose the style, "because of the great architectural possibilities there-in to make a building which would be an outstanding contribution to the architecture of the community of St. Charles, Illinois." Art Moderne and Art Deco took their names from the Paris International Exposition of 1925 and could be characterized as new inspiration, real originality, and forward thinking with emphasis on the future, rather than reflecting on the past. This theme fit and connected well with St. Charles as an emerging town. Zook also surrounded the building with formal gardens, terrazzo walkways, and fountains, taking advantage of its location next to the river.

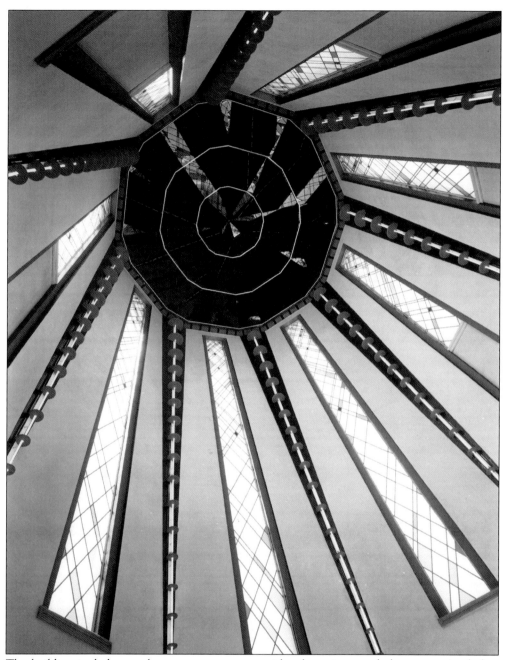

The building includes an elegant octagon tower with a large inset and abstract, stained-glass windows in each of its eight sides. Zook used multi-color fluorescent lighting, relatively new in the 1930s. Construction material included Georgia marble and black granite.

Six

THE NEW FACE
OF ST. CHARLES

Leisure and tourism emerged with the development of structures and attractions, giving St. Charles a cosmopolitan air and elements of distinction. A vast construction project in the latter part of the 1920s included eight buildings (Hotel Baker, the Arcada Theater, the St. Charles Country Club, Illinois Cleaners and Dyers, a grade school to replace the old East Side Grade School, the St. Charles National Bank, the Henry Rockwell Baker Memorial Community Center, and the St. Charles Community High School). Built from 1925 to1928, these eight projects cost $2,250,000. A tremendous philanthropic outreach made this possible. More than anything, this development typifies the progressive spirit of the residents of St. Charles and its newly acquired status.

In 1925, Jacob Crane, Jr., an expert in city planning, described the town: "St. Charles, through the civic interest of a number of its citizens, has taken the lead and set the pace among all the towns of its size in several projects which are making St. Charles famous, namely the community building, the new bank, theater and hotel. These projects have aroused St. Charles to a degree of civic pride and civic ambition which sets the town apart among its contemporaries, and which will have a marked effect upon the success of an ambitiously, but carefully comprehensive civic development plan and program."

The formation of the St. Charles Chamber of Commerce provided new business growth opportunities by aggressively recruiting companies to move to town. In 1926, the total population had reached 5,118 residents. Of them, 1,781 were under the age of 20 years, while only 168 residents were over the age of 70. This was becoming a community of young families, and strong education services were at the forefront of planning efforts. During that period, city leaders recognized the mass introduction of the automobile and the new metropolitan highways would result in substantial population growth.

St. Charles also addressed the future development of the community in a formal manner by appointing a zoning and planning commission in 1925. The purpose of the group was to craft zoning guidelines and a city plan. Eventually, minimum prices were set at various sites to ensure "investment protection" and maintain the lifestyle that attracted many to town. During that time, more than 300 vacant lots existed within the city limits of St. Charles and were priced from $300 to $2,000. The St. Charles Building and Loan Association that was founded in 1891 had also grown substantially, becoming a major financial institution.

By the 1920s and 1930s, St. Charles began to make considerable progress in surpassing historical town divisions between the residential communities of the east and west sides of the river. Over the years, decisions on locating the schools, library, post office, and other services always generated an intense rivalry. The growth of the town and a balanced development helped ease some of these competitive tendencies.

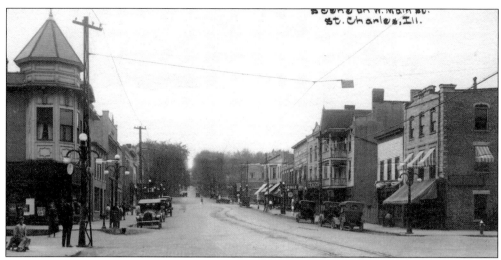

Main Street was paved in 1915 as a result of the continued effort and dedication of Mayor Edwin M. Hunt. Hunt was elected mayor in 1911 and served for 10 years. He contributed greatly to the development of St. Charles by laying crosswalks, rebuilding the electric light plant, completing a new sewer system, adding equipment to the volunteer fire department, and addressing health concerns by enforcing laws to reduce the epidemics of diphtheria and typhoid fever. City sewers were laid in 1912 with a septic tank on the east side of the river. This photograph at Second and Main Streets looks west. The White Front Hotel and the old Dearborn Building are visible on the north side of Main Street.

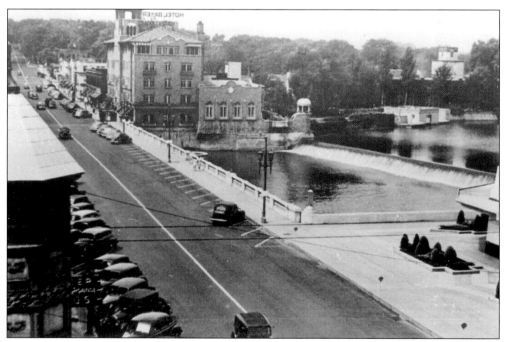

This photograph was taken during the 1940s. The main street bridge was rebuilt in 1927 in a more modern style. There are no tracks on Main Street, as those were removed in 1937. It is during this time that the rail cars stopped running, and traveling to Chicago now necessitated a bus transport to Elgin. Round trip to the city was $1.35.

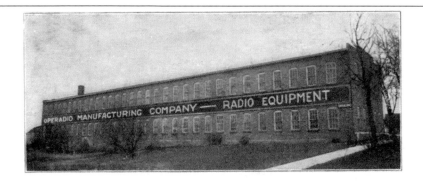

In the late 1920s, the St. Charles Chamber of Commerce actively recruited businesses to town. The Operadio Manufacturing Company started in 1922 in Chicago and moved to St. Charles in 1928. The company produced amplifying systems, sound equipment, and radio speakers. They operated two plants in town, one on the east side, in the old Heinz Cut Glass factory, and another on the west side.

Operadio eventually became known as the DuKane Corp and is still in business today. A number of other business arriving in the late 1920s and 1930s including the Howell Company, Hawley Products, the Stover Water Softener Company, St. Charles Manufacturing Company, Chicago Electrode Laboratories, Pioneer Publishing Company, the Stone Company, and the U.S. Printing and Lithographic Plant.

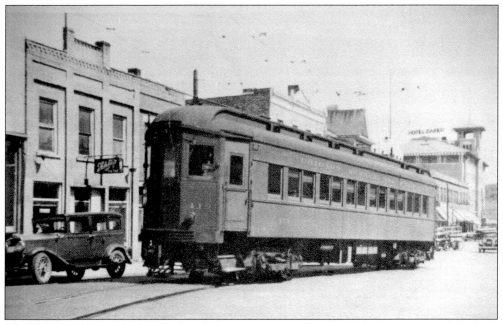

The Chicago, Aurora & Elgin Railroad Company operated eighteen departure times daily from St. Charles to Chicago in 1927. This photograph from the 1930s shows a train on the west side of town. Hotel Baker is visible in the background.

Electric rail transportation to Chicago began operation in 1908, and in 1923, the most modern interurban car was introduced. The cars had leather seats, air breaks, automatic door operators, and other equipment and safety devices. Here, a youngster enjoys a ride on an early streetcar along Main Street.

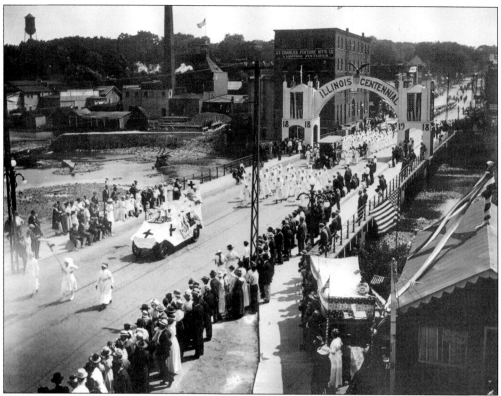

Parades like this one in 1918 during the Illinois Centennial celebration became increasingly notable community events, bringing residents together.

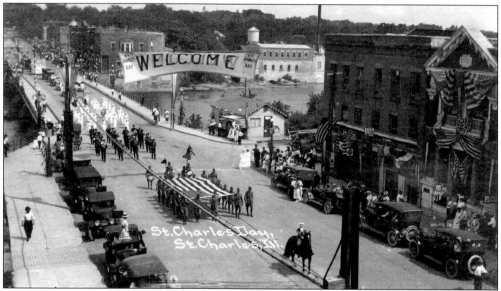

Captured in this early 1920s photograph is a St. Charles Day Parade. The photograph was taken from the building where Colson's was located, on the north side of West Main Street. It looks to the east.

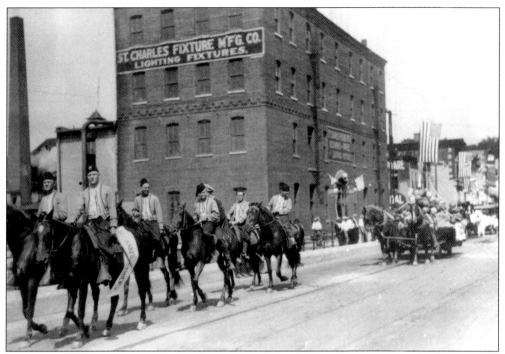

The old St. Charles Fixture Company is in the background of this parade photograph from the 1920s. The building burned down in 1929, and the site was eventually redeveloped as the Municipal Building.

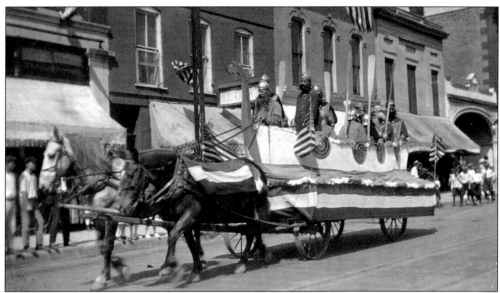

Many benevolent and social organizations existed in St. Charles in the late 1920s. Some of those were DLK Vitautas (Lithuanian), Ledstjernan Society (Swedish), Lithuanian Sons and & Daughters, the Women's Christian Temperance Union, Royal Neighbors, and the St. George Lithuanian Society. The Vikings, Neptune Lodge No. 35, IOV above participate in a Main Street parade.

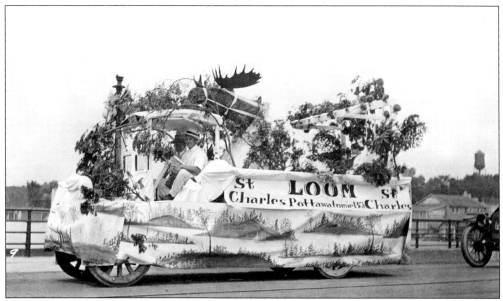

This float at a downtown parade was sponsored by the Pottawatomie Garden Club. The organization was founded in 1928 and is still active, supporting gardening activities, as well as prairie restoration and preservation.

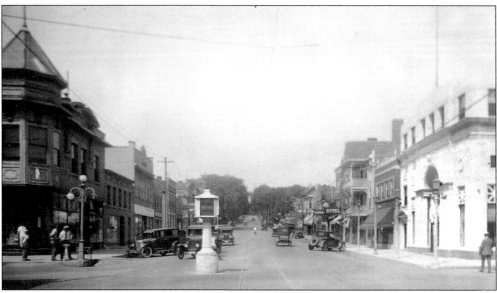

In 1926, Edward Baker tore down the old Dearborn Building at the northwest corner of Second and Main Streets and built a structure made of marble, the St. Charles National Bank. Lester B. Colby of the Illinois Chamber of Commerce described the building: "They opened a bank the other day, and I, rediscovering Illinois, was there to see it. This village bank's home cost about $200,000. It is of marble with beautiful bronze furniture and tall bronze vases and amazing equipment. It is probably the most richly furnished bank of its size in the world. It is complete even to machine-gun emplacements." This photograph facing west was taken in 1933.

The Henry Rockwell Baker Memorial Community Center was also built by Edward Baker at a cost of $200,000. This was the Bakers' first major philanthropic gift. The facility was dedicated in May of 1926 and is located at Walnut Street and South Second Street.

The center was donated in memory of the Bakers' son Henry, who died in 1914 at the age of 23. The English Tudor-style structure provided an assembly hall and stage, lounge, swimming pool, bowling alleys, billiard rooms, kitchens, lockers, and rooms for various social groups. Bedford stone, buff stucco and brown-stained half timbers created a medieval look.

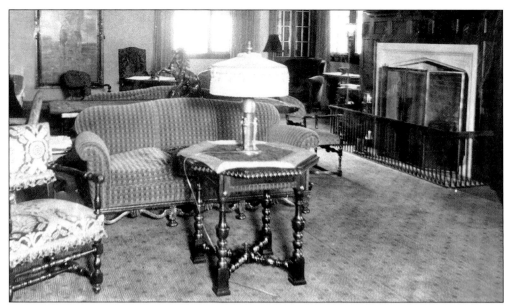

The center was home to the St. Charles Woman's Club, a social and civic city organization that was founded in 1892, and served other groups including the Business and Professional Women's Club, the Boy Scouts, the Camp Fire Girls, the American Legion St. Charles Post No. 342 of the American Legion, and others. It also housed the St. Charles Chamber of Commerce. Many tourists visited the facility, since it served as a general information bureau. The grand lounge, located on the main floor, featured a life-size portrait of Henry Baker in his football uniform.

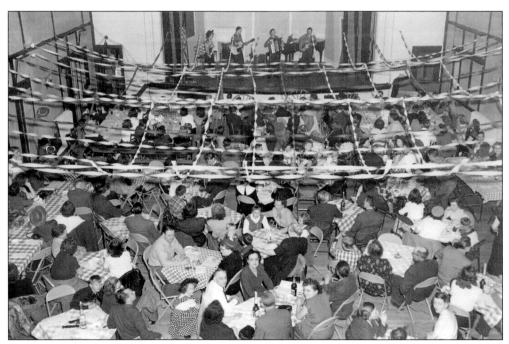

Over the years, the facility was utilized as a central meeting place for civic festivals, community performances, receptions, and a variety of recreational activities. Drama, art, sports, and education for all ages were some of the commonly held activities.

A number of community leaders gathered for this photograph at the Henry Rockwell Baker Memorial Community Center. Seated in the middle of the front row is Mayor Ival G. Langum. He guided the city through the Great Depression years and from 1931–1933 he established a soup kitchen where the unemployed could receive food for their families. According to Betty Beckstrom in *The Mayors of St. Charles*, an eight-hour day of work for the city was equal to six days worth of food.

The officers of I.O.O.F Lodge #14 posed for this 1926 photograph taken at the Arcada Theater Building, which housed many social organizations. Arthur Roehlk, son of Mayor Henry Roehlk (1921–1929) is pictured in the middle of the top row. Mayor Roehlk was born in Denmark in 1863 and came to St. Charles in 1882. During his terms as mayor, the dairies were required to lengthen their smoke stacks to prevent smoke from blowing into nearby homes and Geneva Road was paved from Second Street to the south city limits. In addition, the street superintendent was instructed to clean four to five hundred square feet of snow from the river for skating and to install suitable lighting.

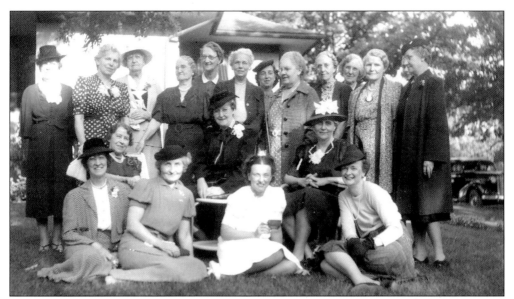

Women's clubs were very vibrant during the 1920s and 1930s. The St. Charles Mothers' Club was founded in 1924 with the aim of promoting better health for children and educating mothers in childcare. The group also raised money for the hospital nursery. Ruth Ericson, Dellora Norris, and Althea Potter were among the founding members of the club. Members of another organization, the Garden Club, posed for this photograph. They were very active and participated in numerous community service projects, including landscaping the exterior of the Henry Rockwell Baker Memorial Community Center.

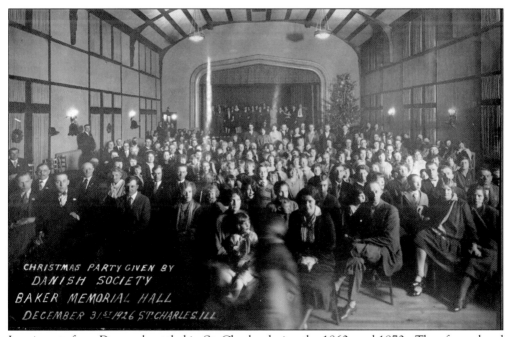

Immigrants from Denmark settled in St. Charles during the 1860s and 1870s. They formed and participated in numerous social organizations. The Danish Brotherhood, Lodge No. 92 and the Danish Ladies' Society were two of the most popular groups.

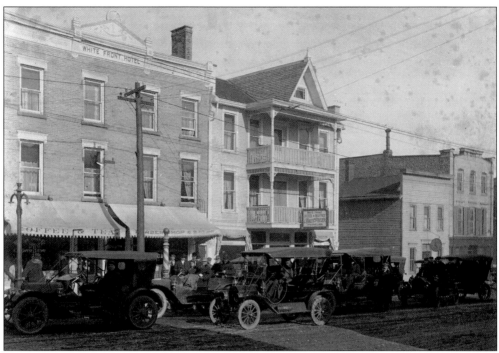

Since the 1850s, St. Charles has been home to numerous hotels. Most of them eventually disappeared, excepting the White Front Hotel. Erected in 1851 by John Billings on land between Second and Third Streets, the hotel changed hands many times. In 1928, it was leased to Louis Kacheres, a Greek immigrant whose family operated it as a hotel and restaurant. The building housed local transients, hosted civic clubs, and provided entertainment to residents for many years. The name is still visible on the front of the building.

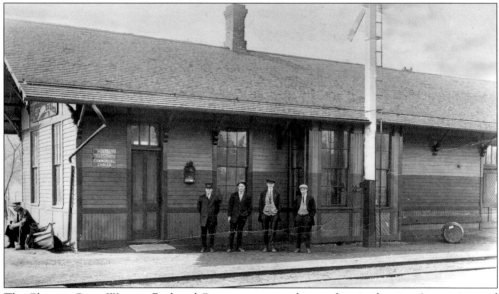

The Chicago Great Western Railroad Company operated a spur line in the city. A morning and evening stop included the transport of freight goods.

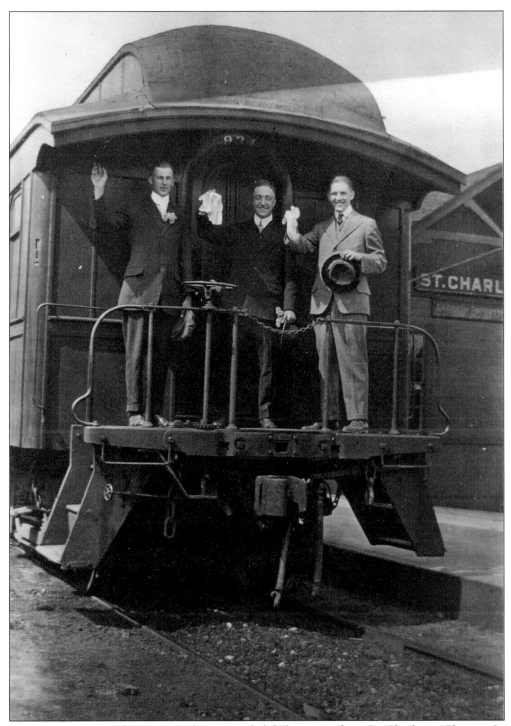

The Chicago & Northwestern Railway provided daily service from St. Charles to Chicago. In 1927, the schedule included three morning and three evening runs. Depending on the stops, it took one-and-a-half to two hours for a one-way trip. The depot above was located on the east side of town.

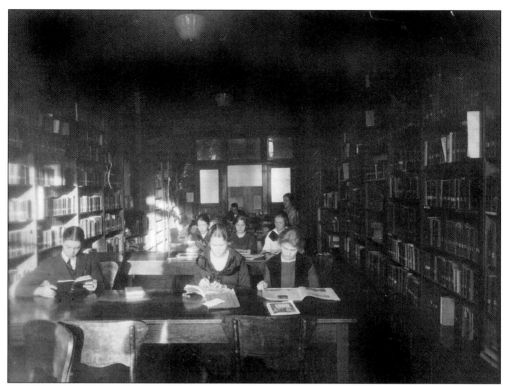

In the late 1920s, St. Charles had three grade school buildings, a junior high school, and a high school. In 1926, 875 students were enrolled in the grade schools and 225 in the community high school. In 1930, St. Patrick's Parochial School was introduced on the west side.

The St. Charles Community High School was built in 1926 at a cost of $250,000. The 14.5-acre campus included football fields, baseball fields, and tennis courts. A gymnasium and auditorium seating 800 and a cafeteria were also added.

The high school was also equipped with state of the art laboratories, science lecture rooms, and facilities for home economics. The curriculum included courses in social science, English, mathematics, physics, chemistry, and biology.

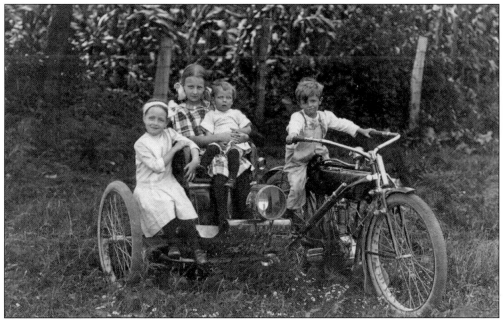

The children above pose for an outdoor photograph around 1910. Residents of St. Charles in the 1920s and 1930s prided themselves on experiencing life in a community that was surrounded by fields and embedded in the natural beauty of the Fox River. A special federal census in 1926 reveals that 1,287 families lived here with home ownership rate of 67.2 percent. The majority were employed in town with the exception of 174 individuals working in Chicago, 88 in Geneva, 41 in Elgin, 34 in Batavia, and 13 in Aurora.

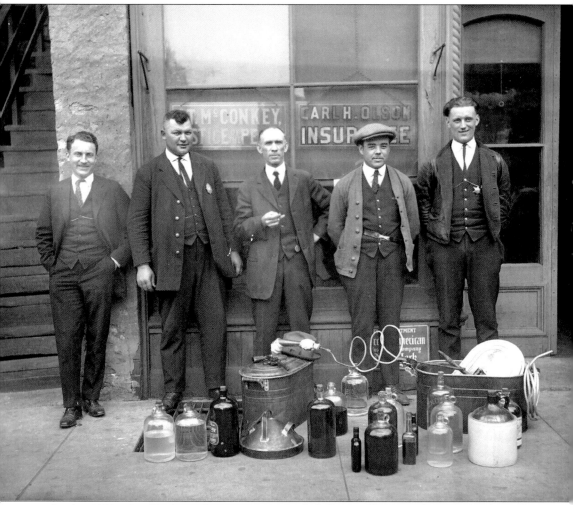

In the 1920s, St. Charles police protection included two officers working twelve-hour days, seven days a week. The offenses were minor. "Woman is fined for selling booze here," reported the June 6, 1918 *St. Charles Chronicle*. The same paper commented: "Hooch studio raid; cow food taken," in the October 27, 1921 issue. The photograph above shows the spoils of a raid that includes a brew kit and a gun.

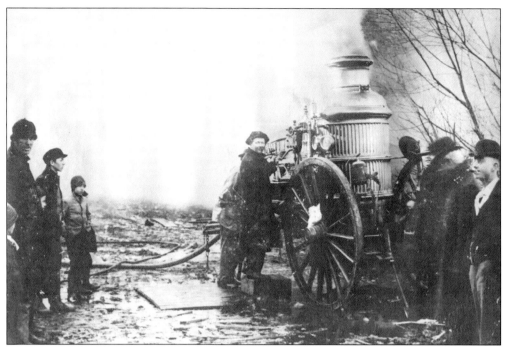

This 1895 photograph shows the town's steam fire engine. The fire department was founded in 1842; given the predominantly wooden structures in town, it continually battled fires.

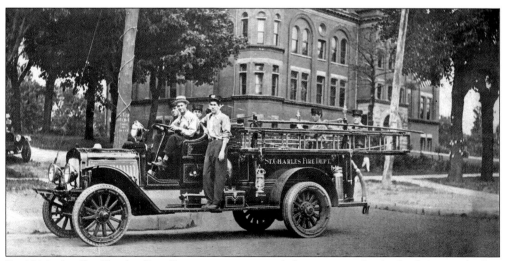

By 1916, the St. Charles Fire Department possessed this motorized vehicle shown parked in front of the school. Until that time, horse drawn carriages were employed, and up until 1910, water was pumped from the river, making fighting fires even more difficult to quench.

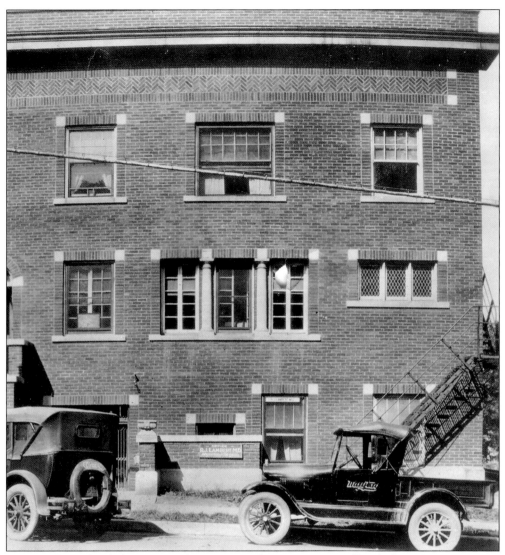

City residents battled many epidemics over the years, especially cholera. Dr. Henry M. Crawford, an Irish immigrant, served the population until his death in 1900. The Lambert hospital (above) at 316 West Main Street was erected in 1913 by Drs. R.J. and Edith Lambert and was used until 1925. Edith Lambert continued her service by operating a summer health camp out of her Orchard Hill home north of St. Charles.

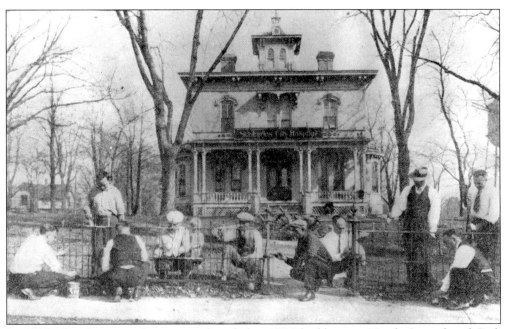

In 1925, the American Legion purchased this 1876 building on North Second and Park Avenues and converted it into a 20-bed city hospital. Members of the American Legion Post 342 are shown here painting the fence in 1927. This city hospital closed in 1935 due to financial difficulties.

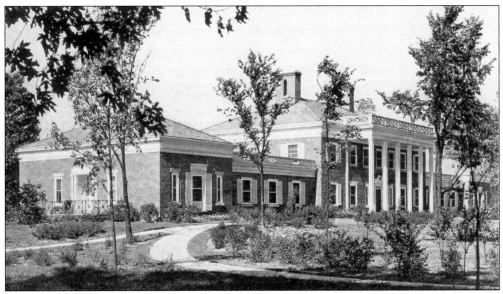

In 1939, the Norris family began building the 35-bed Delnor Hospital. Built on North Fifth Avenue, this Colonial Revival-style structure adequately served the needs of St. Charles for many years. In the early 1970s, following successive expansions, the hospital size increased to 105 beds.

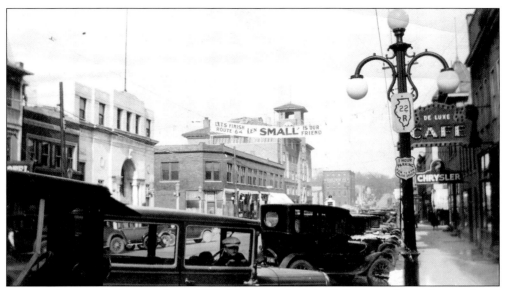

Among the town's theaters from 1920–1930 was Irwin's Hall, located on the southeast corner of Second and Main Streets. The Hall presented shows, dances, and moving pictures. Entertainment was also provided by a variety of musical organizations. Among them was the St. Charles Band, which played alternately at Baker Park and Lincoln Park. This late 1920s photograph shows the newly built Hotel Baker and St. Charles National Bank.

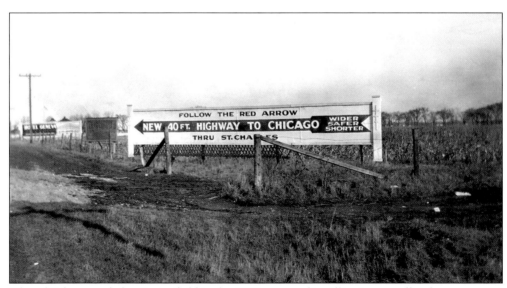

Edward Baker traveled to Springfield in the 1920s, persuading Illinois state officials to construct Route 64 through the heart of the town. The newly built route encouraged travelers to venture west. Eventually, it became a main thoroughfare for pleasure seeking visitors from Chicago and the surrounding areas.

Seven

CULTURE AND LEISURE IN LATER YEARS

Samuel Evans, of the Wallace Evans Game Farm, noted in the 1920s: "A radical and profound change is taking place in the attitude of city dwellers in America toward country living. Those who can afford to live in the country, at least through the open season, are making the exchange in constantly increasing numbers. This is the reason why the beautiful Fox River Valley will soon have a population which now seems impossible to most of its inhabitants. Chicago and its more crowded suburbs are going to send us those of their people who have awakened to the fact that a well-rounded life calls for something of the freedom, the activity and the contact with nature which can be had only in the country. The wealthy and well-to-do people of the English cities learned this long ago. I am glad to live in a community that is keenly appreciative of all this. In building for the future St. Charles is in the lead. In this it exemplifies the spirit of the entire Fox River Valley."

Since the end of World War II, St. Charles has maintained its position as a cultural attraction, providing entertainment and leisure opportunities to locals and visitors alike. A variety of recent projects propelled the town in that direction, including the Kane County Fair (1954), Pheasant Run Resort and Convention Center (1962), the Dellora A. Norris Cultural Arts Center (1978), and the Scarecrow Festival (1985), among others. In recent years, the community has been actively engaged in redeveloping its downtown area and riverfront. Its aim has been to convert its unique position on the Fox River into a destination spot for tourism, leisure, and entertainment, resurrecting once again its glorious past.

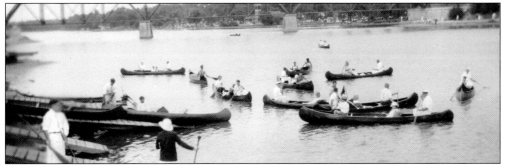

Over the years, many community events continued to center on the entertainment and leisure opportunities of the Fox River. Regattas and boating were very popular. The canoes in this late 1920s photograph are launched from the boat housing area behind Hotel Baker. A large crowd is visible in the background around the pavilion at Pottawatomie Park.

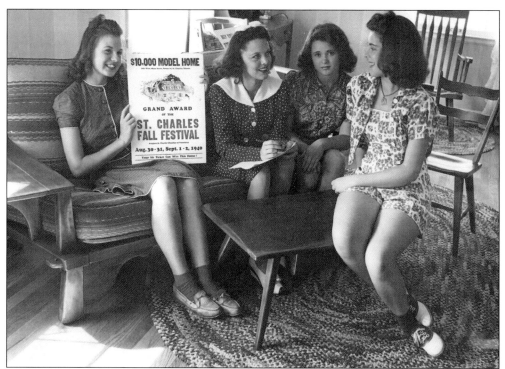

The St. Charles Fall Festival began in 1937 and ran from August 30 to September 2. With the support of Mayor Langum, the members of the planning committee introduced a 50-cent raffle that could win a $10,000 "dream home." The prize was the centerpiece of the festival in 1940, and the new house was located on West Main Street, adjacent to the St. Charles High School.

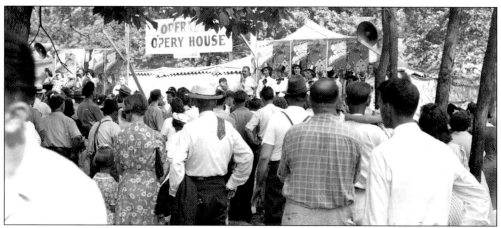

Events at the 1940 St. Charles Fall Festival included a softball tournament, speeches and concerts at Pottawattamie Park, a Venetian Night Regatta on the Fox River, a style and fashion show at the amphitheater, a fishing contest, a diving meet, a Belgian Bowling contest, and a tug-of-war contest. According to the program: "Dancing every night at Pottawatomie Park to music of Pottawatomie Park Band, starting at 8:00pm—Dancing Hotel Baker, Dining Room, Saturday, starting 9:00pm and Floor Shows at 10:00 and 12:00pm, music by Carl Schreiber's Blue Heaven Rhythm Band—American Airlines invited to give an Air Show over St. Charles on Saturday and Labor Day Monday afternoon."

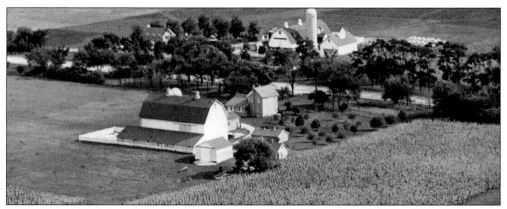

In the late 1950s, Edward J. McArdle, a real estate developer, purchased the Wallace Evans Game Farm. The farm was first established in 1895 in Oak Park, Illinois, and then in River Forest, Illinois. In 1914, the farm relocated to St. Charles, north of Route 64, at the end of Dean Street. The farm raised pheasants and supplied conservation groups with eggs for incubation. This farm was well known across the country. Hunters were attracted to the area for sporting purposes and even Ernest Hemingway mentioned it in his novel *Green Hill of Africa*. After buying the farm, McArdle took up residence on part of the property and named it "Pheasant Run." In the early 1960s McArdle noted that there wasn't a good steak house between Chicago and Rockford, Illinois. He partnered with Dudley Stetzer, a restaurant businessman, and together they purchased Airport Farm, a 175-acre property east of St. Charles along North Avenue, for $1,470 an acre. Airport Farm was a dairy farm, owned by Edward J. Baker. An airstrip had been developed there in 1928 to the east of the property. Numerous buildings, including a main barn, stock and animal barns, a milk house, and a seven-room farmhouse occupied the property.

McArdle and Stetzer converted the main barn into a restaurant. A debate ensued between the partners over the need for a liquor license. Stetzer, a devout Baptist, opposed the idea, which resulted in a split and a buyout of Stetzers' share of the partnership by McArdle. In February 1962, McArdle opened his restaurant and named it Pheasant Run for his home on the west side of St. Charles. Dinner theater was introduced in June of 1964, and the next year, a 150-room addition was completed. In time, additional restaurants, a cobblestone Bourbon Street interior, swimming pools, a health club, a golf course, tennis courts, a 15-story hotel and a large exhibition hall transformed the facility into the Pheasant Run Resort and Convention Center. The resort has attracted many performers and politicians over the years, including George Bush, Charlie Daniels Band, Tom Jones, Jay Leno, Governor Thompson, Tanya Tucker, and many others.

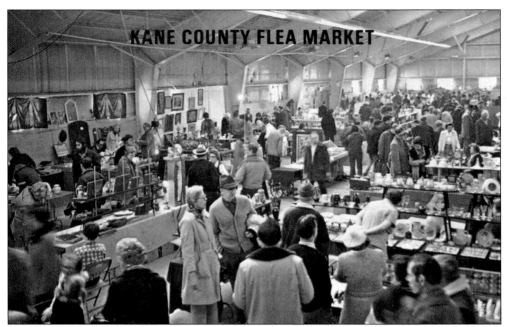

The Kane County Fair moved to St. Charles in 1954 and is currently in its 137th year. The fair is operated by the Kane County Fair Association, a private, non-profit organization. Thousands of visitors from all over the Chicago area and across the Midwest visit the grounds. Events include car shows, rodeos, doll shows, trade shows, auctions, festivals, and concerts. The fair typically draws over 100,000 visitors to the area each year.

One of the most popular events at the fair is the Kane County Flea Market. The flea market was started in 1967 by Helen Robinson, who made the event a year-around occurrence in January of 1968. Robinson became known as "Queen Flea," and the market draws 20,000 people daily during the summer months. As many as 1,000 vendors sell their goods in various indoor and outdoor buildings. *Good Housekeeping* and *Money* magazines ranked the Kane County Flea Market as one of the Top 10 Flea Markets in the country.

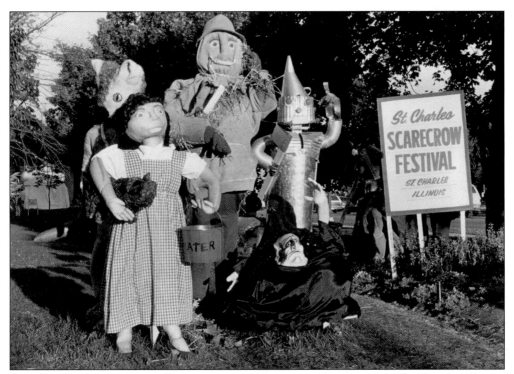

The St. Charles Scarecrow Festival was established in October of 1985. The St. Charles Convention and Visitors Bureau has been responsible for the organization, coordination, and presentation of this annual event. The first festival had just five scarecrows as businesses and residents were asked to contribute to the event held in Lincoln Park on West Main Street at Fourth Street. Over the years, entries have grown to about 110 scarecrows from across the state, the Midwest, and even outside the country (Japan in 2000).

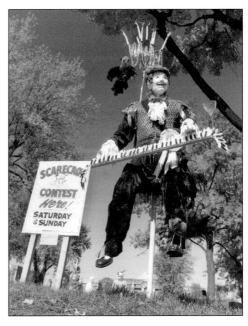

The St. Charles Scarecrow Festival has been recognized with awards from the American Bus Association, the *Leisure Group Tour Magazine* and the Illinois Special Events Network. Children's activities have expanded over the years, and sing-alongs, jugglers, jousters, dancers, and drum corps keep the action lively with numerous performances. Attendance at the event has grown to between 80,000 and 90,000 visitors.

In 1972, Dellora and Lester Norris donated the 70 acres of land on which the St. Charles East High school campus sits today and made an initial gift of $4.25 million toward construction of a cultural arts center and a recreation center. The school opened in 1977, followed by the Dellora A. Norris Cultural Arts Center in 1978, the Lester J. Norris Sports Complex in 1980 (with an additional $2.5 million grant from the Norris family), and the John B. Norris Recreation Center (named for one of the couple's children). The Dellora A. Norris Cultural Arts Center includes a 1,000-seat performing arts theater and art gallery. It was founded in 1978 with funding from the St. Charles Charities, which was created in 1924 by Lester and Dellora Norris and Edward Baker. In a 1978 letter, Lester Norris, outlining his financial support for the project, noted: "You have the machine and I am proposing to furnish some of the fuel to make it run."

The center was designed by the architectural firm of Unteed, Scraggs, Fritch, and Nelson of Palatine. The stage is 40 feet deep and 72 feet wide and includes 69 separate fly lines to be used for flats, battens, and backdrops. The orchestra area in front of the stage is hydraulically operated. It can be raised to become part of the stage or lowered from view. The theater includes areas for set construction, dressing rooms, and rehearsal rooms. Each year, 25 to 30 student, community, and professional shows take place, and the facility is utilized roughly 265 days a year. The first show was a high school production of *Fiddler on the Roof*. Over the years, performers have included the No Center Aisle Theater Community Group, violinist Itzhak Perlman, the Chicago Symphony Orchestra, singer and dancer Rita Moreno, singer Louise Mandrell, world-renowned pianist Victor Borge, Second City, and former Beach Boy and St. Charles resident Brian Wilson.